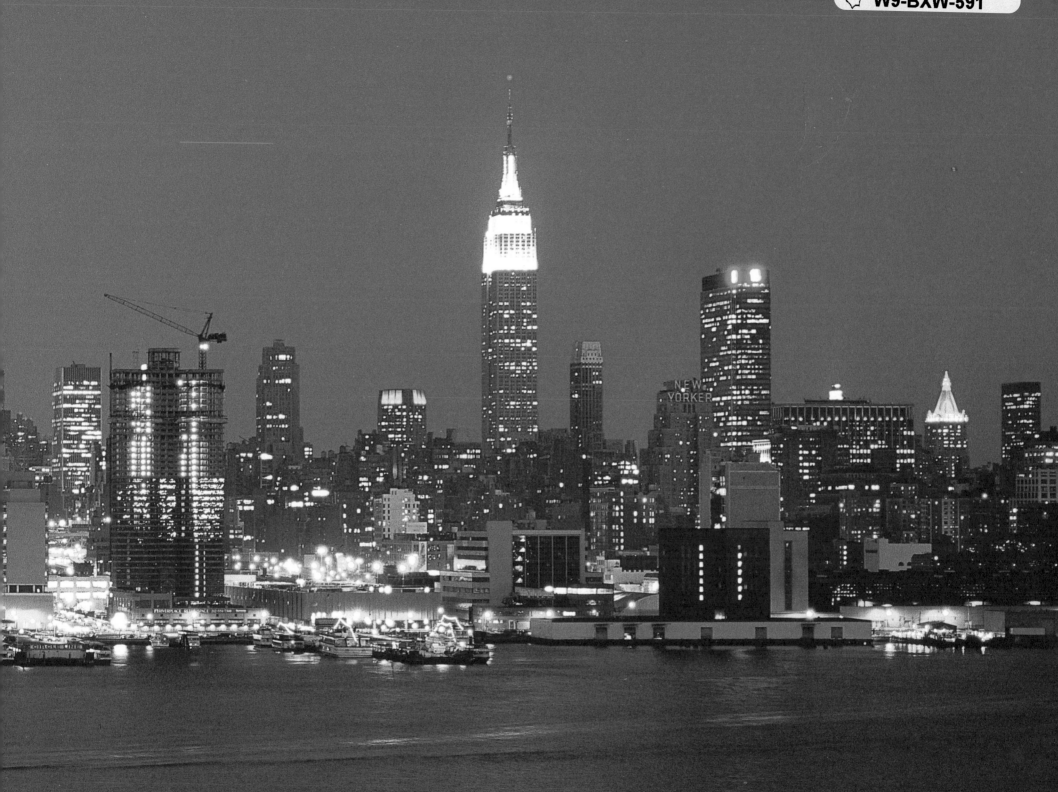

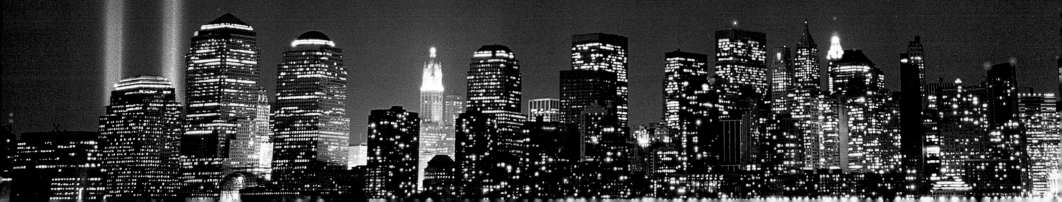

In Memoriam

September 11, 2001 is a date none of us will forget.
An appalling act of terrorism took away the lives of 2.749
people. It is to those men and women that I'd like to
dedicate this second edition of my book.

The first edition was published only one month earlier, on
August 15, and featured the World Trade Center prominently
on the front and back covers. It was probably the last picture
book of New York released before the city was changed forever.
Photographing the city again, and seeing those changes first-
hand, has been a truly haunting experience.

I was impressed, however, by the indomitable spirit and
kindness of New Yorkers. They endure, persevere, and rise
above most any obstacle. If there is any consolation, it is that
New York remains one of the most exciting, vibrant, and
photogenic cities in the world.

— Bob Krist, author/photographer

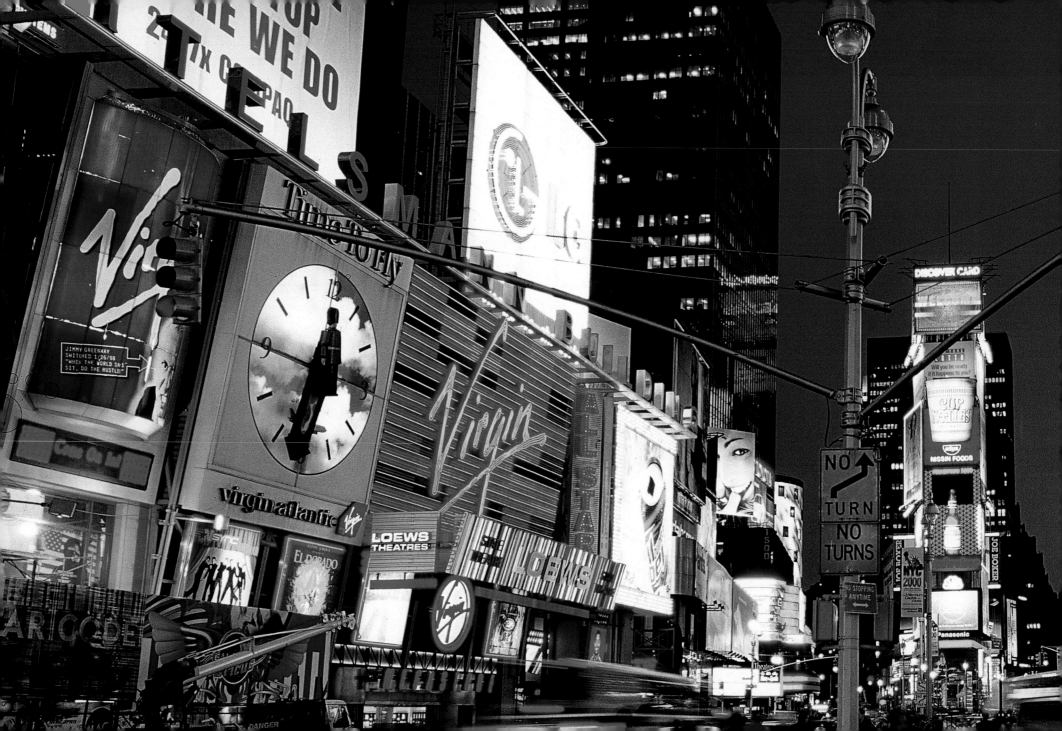

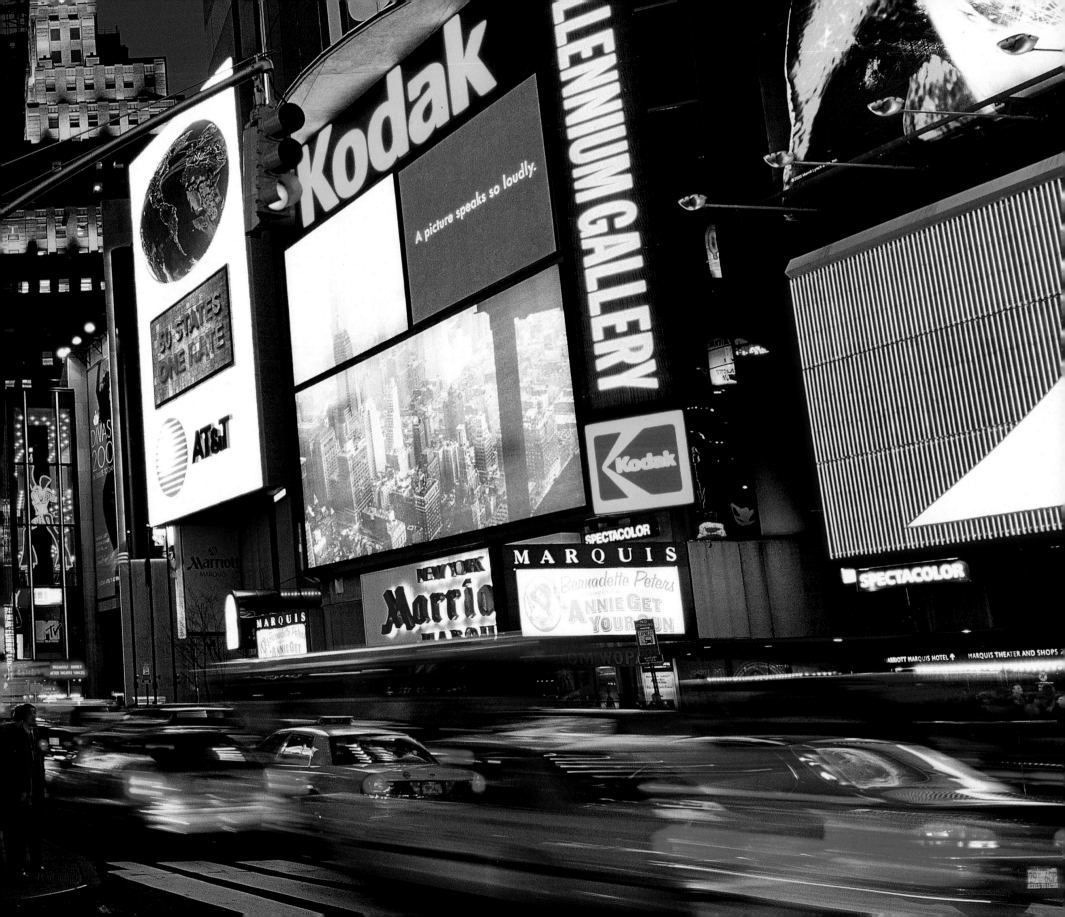

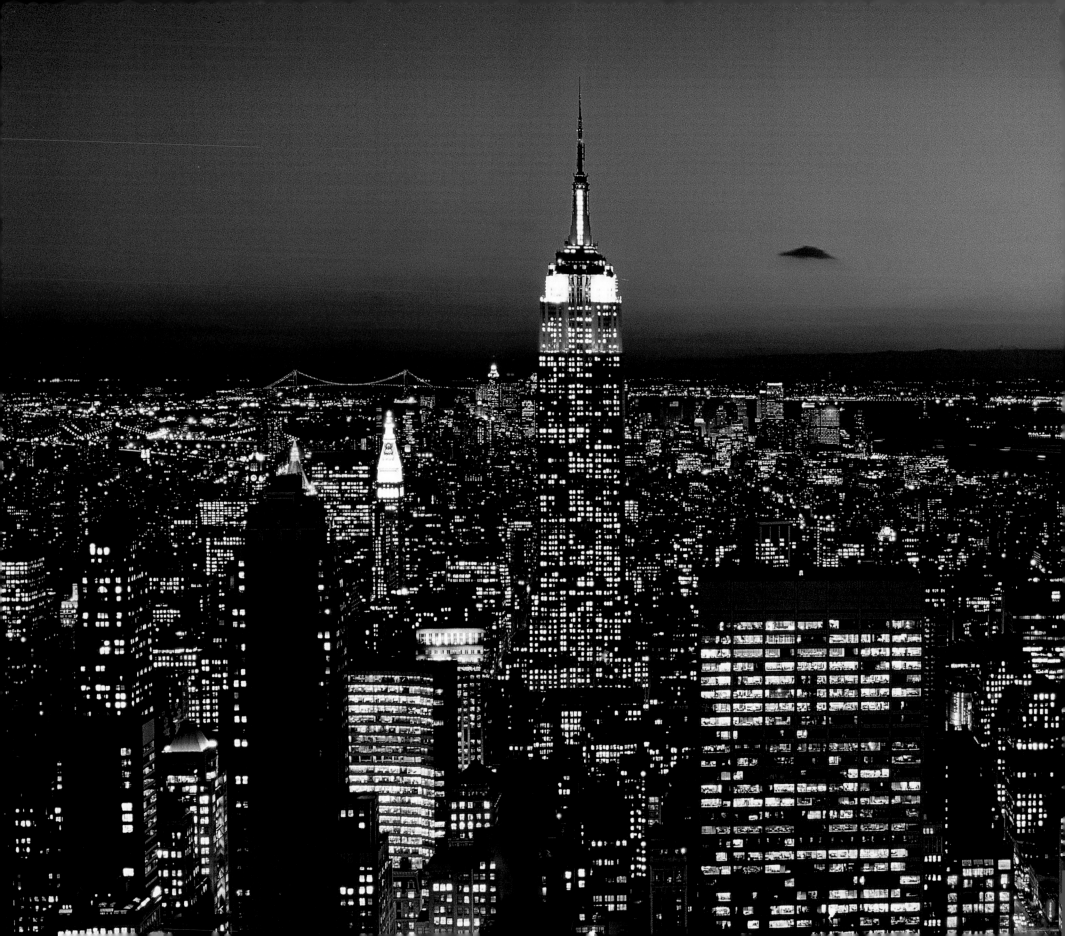

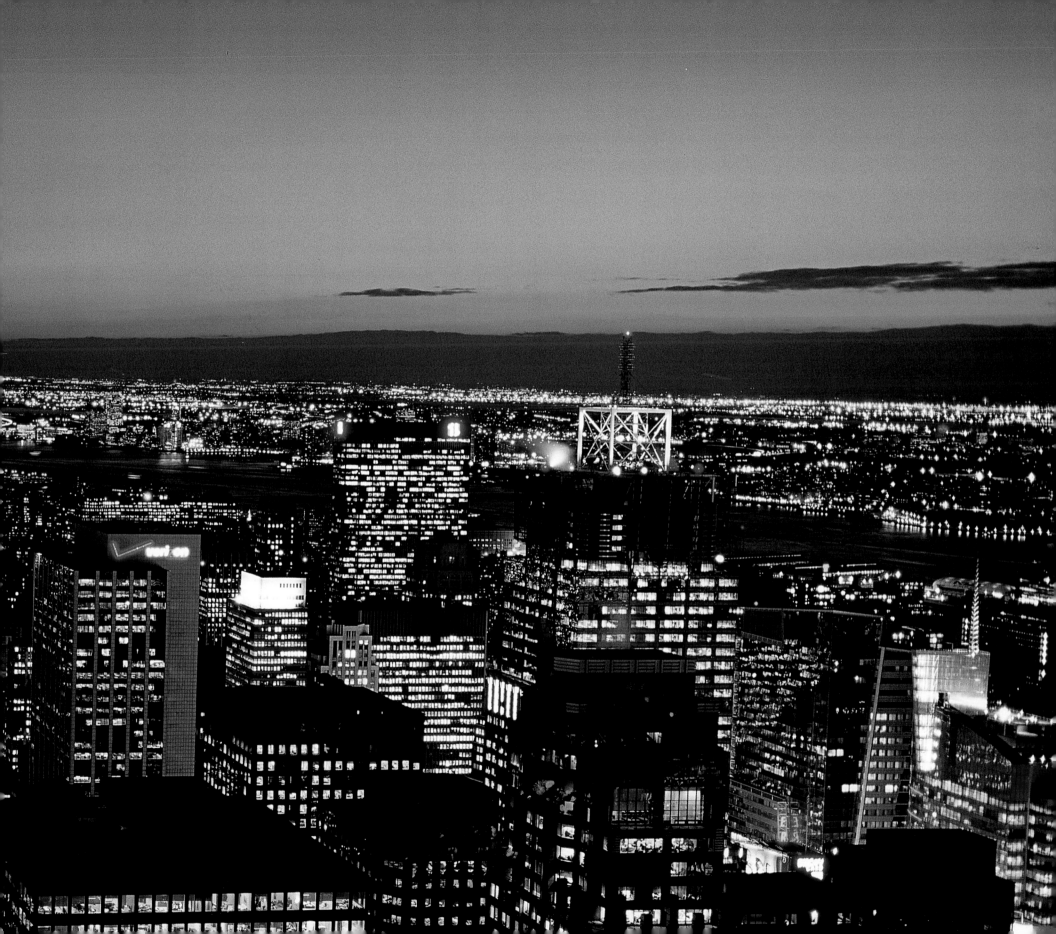

About the Author/Photographer

Renowned travel photographer Bob Krist has been photographing New York for many years.

Bob is a contributing photography editor for *National Geographic Traveler* and *Popular Photography*. His photos regularly appear in *Islands* and *Smithsonian* and his previous books are "Spirit of Place: The Art of the Traveling Photographer" and "In Tuscany" with Frances Mayes.

Bob lives with his wife Peggy in New Hope, Pennsylvania, 60 miles west of Manhattan

For stock photography requests contact Bob Krist on 215-862-4828 or via email at BobKrist@aol.com.

Published by:
Photo Tour Books, Inc.
9582 Vista Tercera
San Diego CA 92129
Tel: 858-780-9726
phototourbooks.com

Distributed to the trade by:
National Book Network
(NBN), tel: 800-462-6420

Designed by Andrew Hudson
Photos © 2001-2006 Bob
Krist. bobkrist.com
All photographs were shot on
Kodak Elitechrome films using
Nikon cameras and lenses and
a Hasselblad X-Pan for the
panoramics.

Paperback:
ISBN: 978-1-930495-45-6
Hardcover:
ISBN: 978-1-930495-46-3

Printed in 2007
Second edition, first reprint.
(Print history: 1st ed. 2001;
2nd ed. 2003, r2007).
Book © 2001-2006 Photo
Tour Books, Inc.

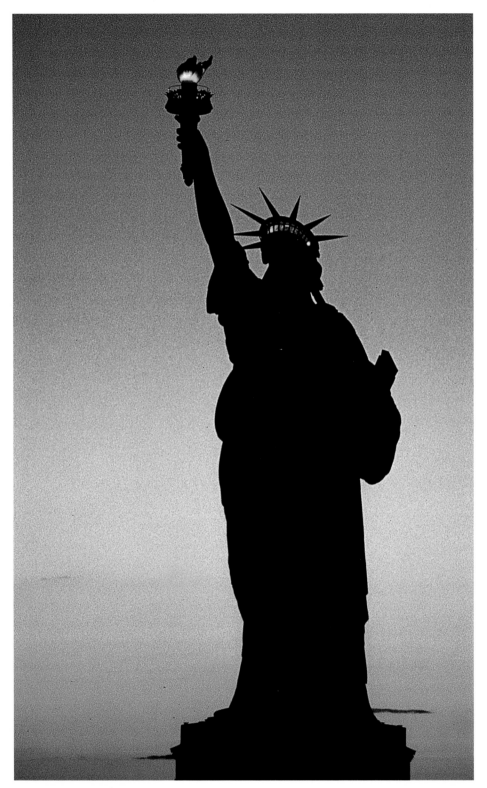

The Statue of Liberty at dusk.

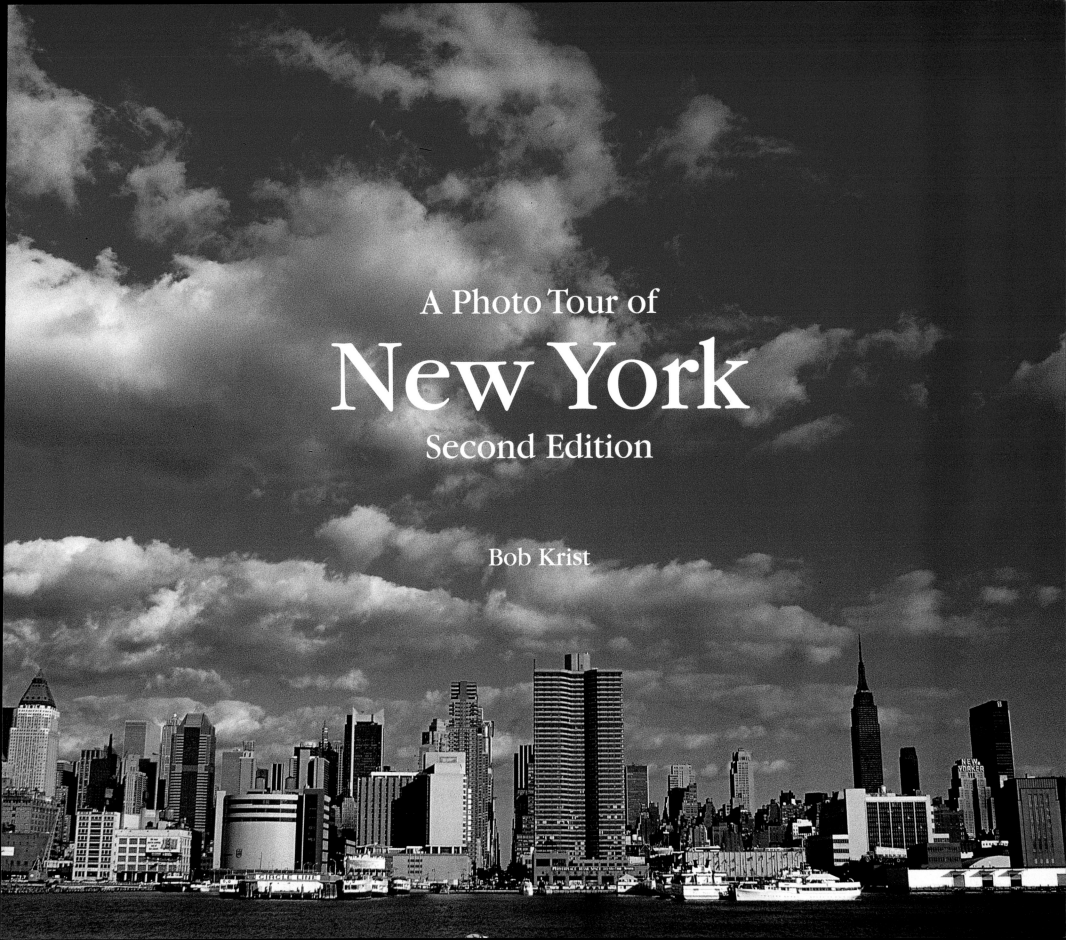

A Photo Tour of

New York

Second Edition

Bob Krist

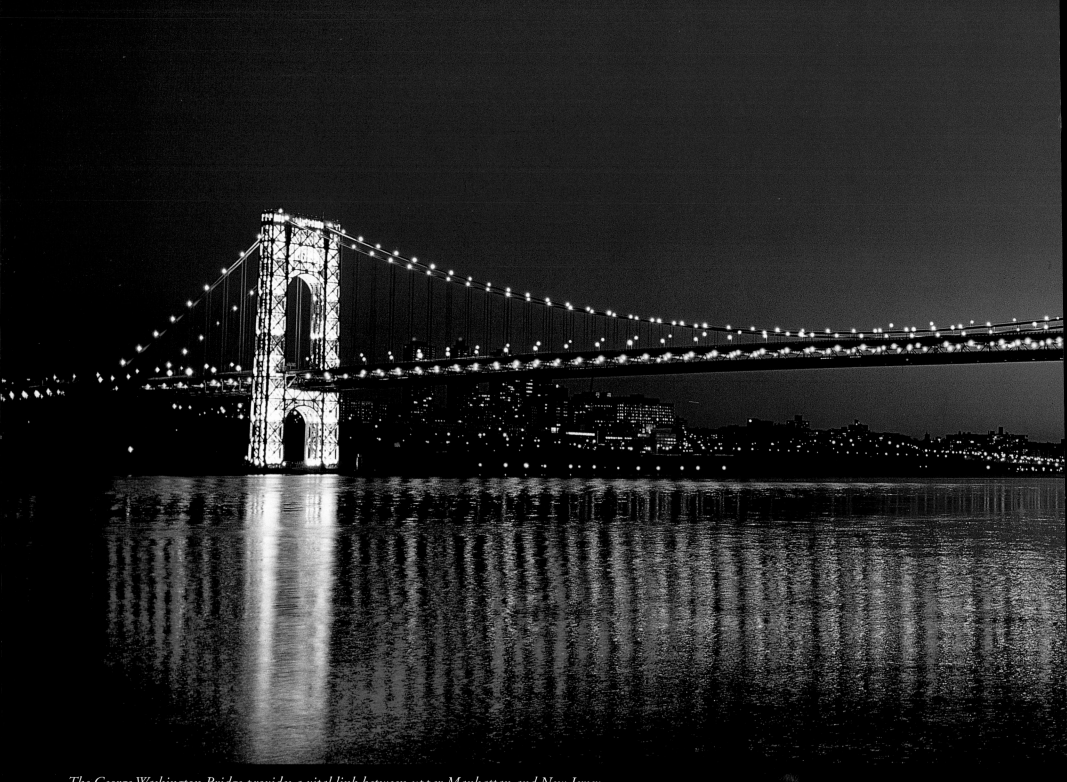

The George Washington Bridge provides a vital link between upper Manhattan and New Jersey.

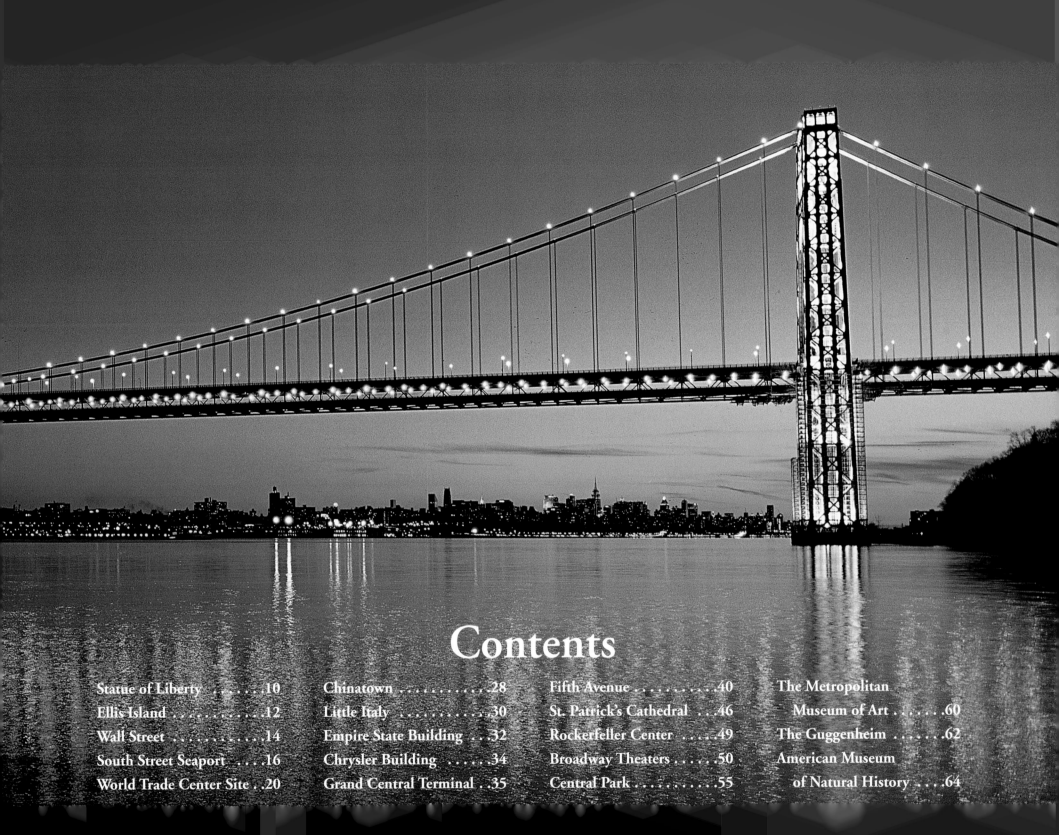

Contents

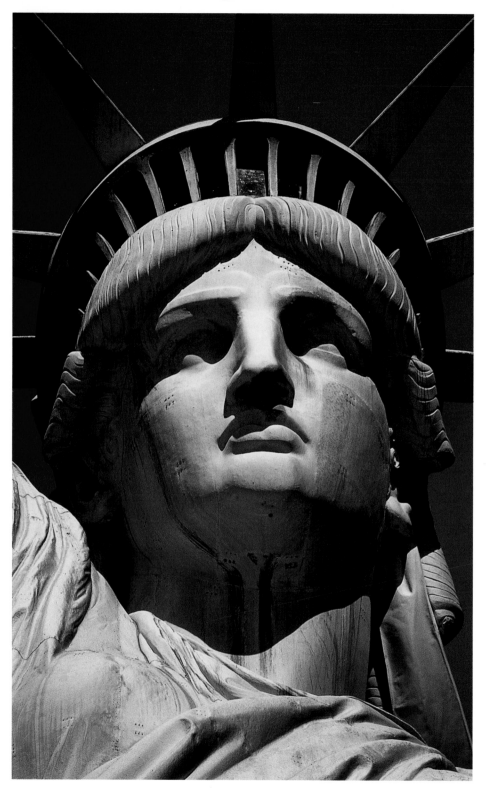

Statue of Liberty

*"Here at our sea-washed, sunset gates shall stand
a mighty woman with a torch…
From her beacon-hand glows world-wide welcome."*
— Emma Lazarus, "The New Colossus," 1883.

Symbolizing freedom and promise, the Statue of Liberty is the icon of America. Facing the entrance to New York Harbor, she welcomed European and other immigrants arriving at the land of opportunity.

In her hands, Liberty holds a flame to enlighten the world and a tablet that reads, in Roman numerals, "July 4, 1776" the day of America's independence from Britain. The Statue was a gift from the French people to America to commemorate the alliance between the two countries during the American Revolution. She was designed by Gustave Eiffel — the French engineer who created Paris' Eiffel Tower — and built by sculptor Frederic Bartholdi.

The Statue of Liberty was dedicated in 1886, following a journey from Europe to New York, similar to the journeys taken by millions of immigrants before and after her.

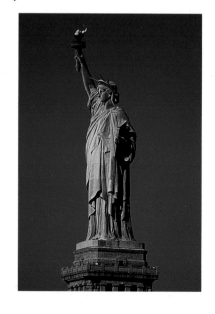

The seven seas and continents are represented in Liberty's seven-pointed crown.

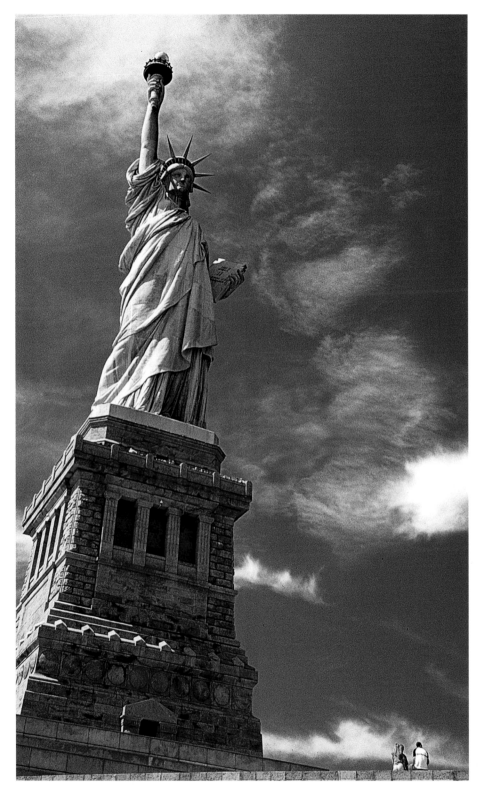
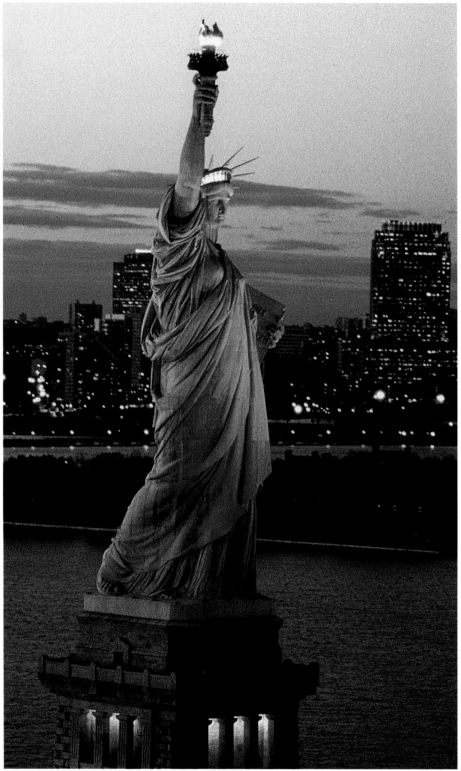

From every angle, the Statue of Liberty is an awe-inspiring figure.

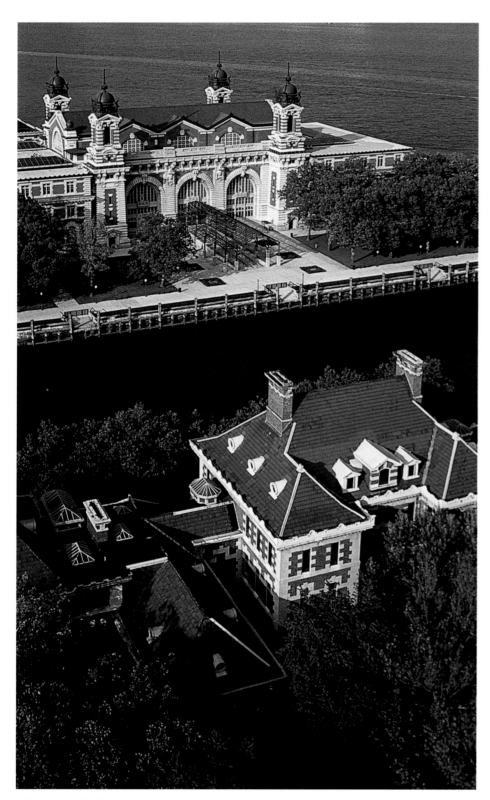

Ellis Island

"Give me your tired, your poor,
your huddled masses yearning to breathe free."
—Emma Lazarus, from "The New Colossus"

It is said that more than 40% of Americans have at least one relative who entered the country through Ellis Island. Between 1898 and 1924, over 16 million immigrants arrived here and approximately 5 million of those took up residence in New York. Ellis Island became known as the "Island of Tears" because of the wrenching stories of the people processed by this port of entry.

Today, the island houses a museum that features a Wall of Honor engraved with the names of thousands of immigrants. Among the many who passed through were luminaries Irving Berlin, Frank Capra, Bela Lugosi and Rudolph Valentino.

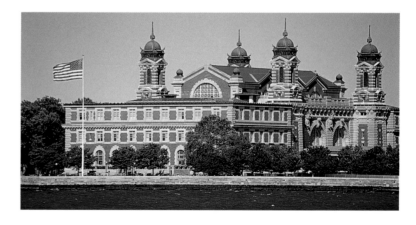

The "Island of Tears" was the first stop for many immigrants.

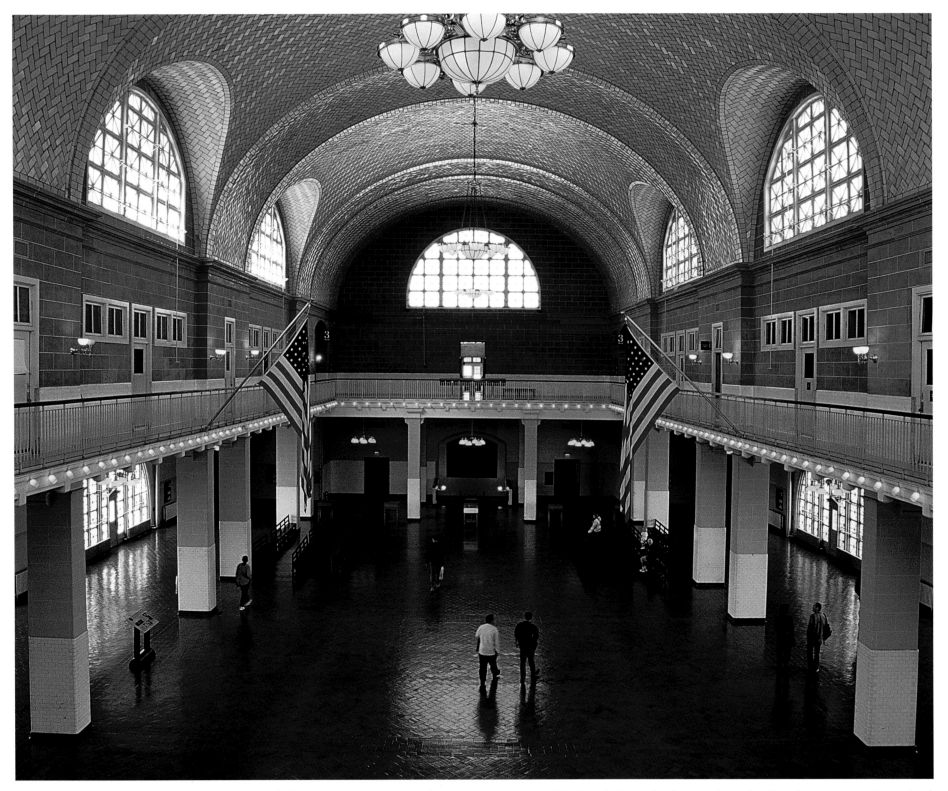

The huge Registry Room is where immigrants waited before their medical, mental, and political status were determined.

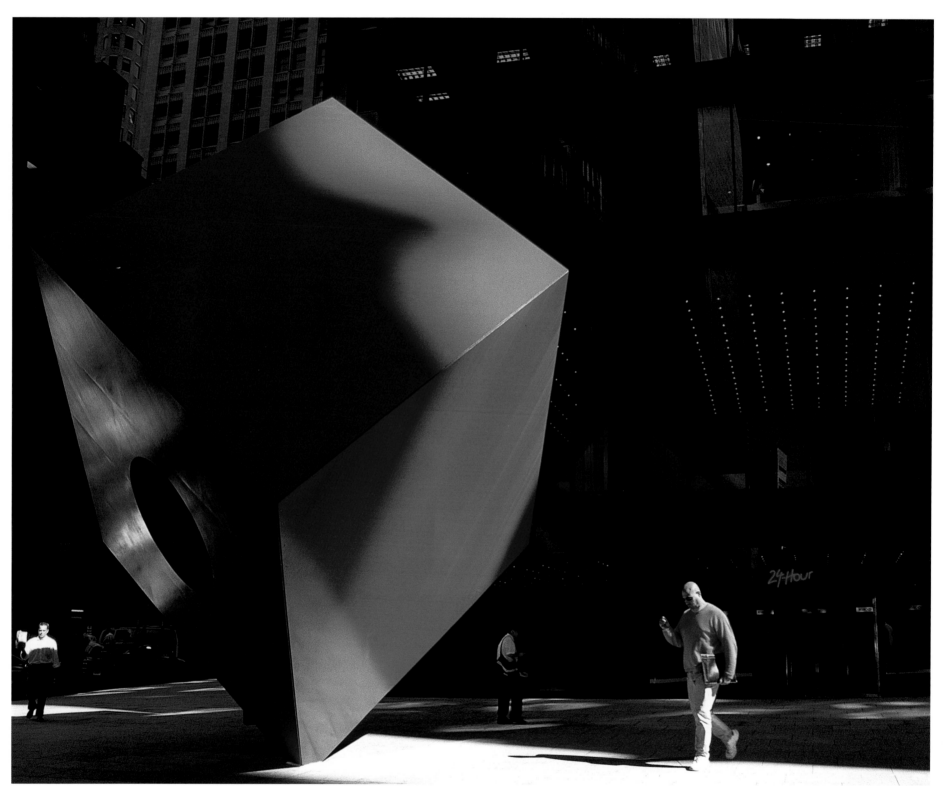

The Red Cube, by sculptor Isamu Noguchi, provides a bit of balance for walkers on Church Street near Wall Street.

Wall Street

"The point is, ladies and gentlemen, that greed,
for lack of a better word, is good.
Greed is right. Greed works."
— Michael Douglas as Gordon Gecko,
"Wall Street," 1987.

The worldwide symbol for ambition, success, and greed, Wall Street has become synonymous with the whole of New York's financial district. Ticker tape parades, closing bells, stock market crashes, and nothing less than the global economy all have a home here.

The "wall" dates from the 1600s when a wooden stockade was built by the Dutch to protect against attacks by the English

and Indians. In the 1790s, a group of stock traders signed the Buttonwood Agreement, named for the buttonwood tree under which they did business. In 1903, the venerable New York Stock Exchange building opened at the foot of the world's most famous street — Wall Street.

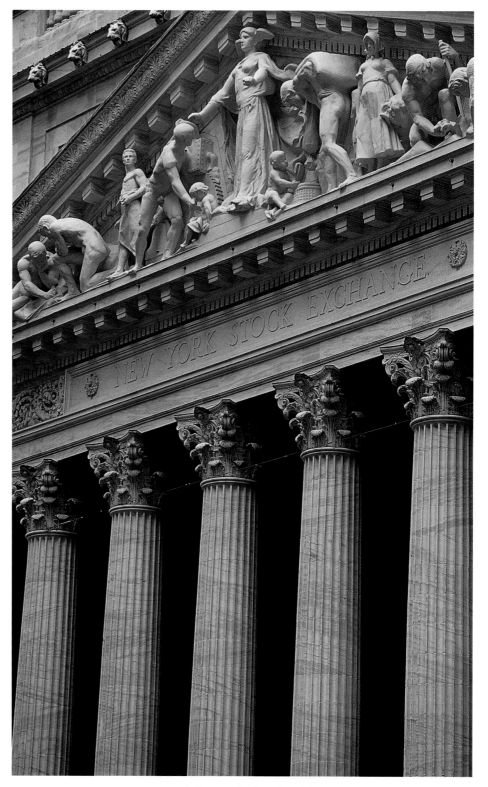

The stately facade of the New York Stock Exchange.

15

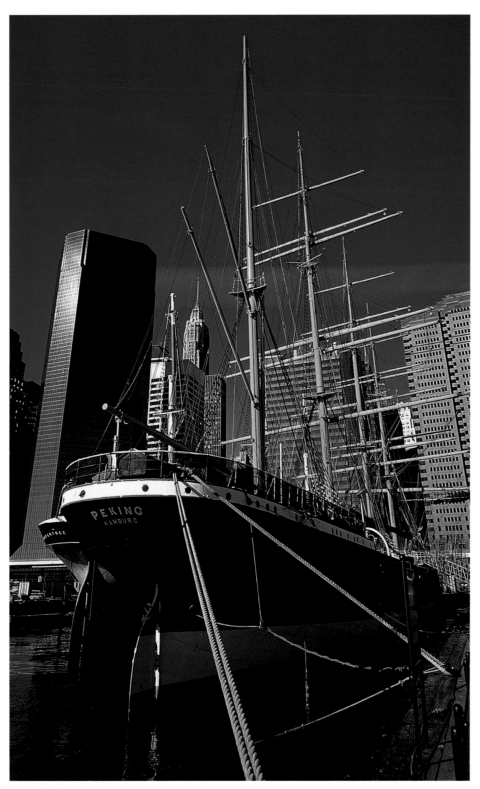

South Street Seaport

*"Sometimes from beyond the skyscrapers,
the cry of the tugboat finds you in your insomnia, and you
remember that this desert of iron and cement is an island."*
— *Albert Camus*

Like many Lower East-siders, this complex on the East River has a past. Formerly a bustling seaport, it was favored by early 19th-century sea captains because it was protected from harsh westerly winds and ice floating down the Hudson River. The area fell into decline until the 1970s when preservationists and realtors joined forces to begin restoration.

Today, the 11-block, South Street Seaport Historic District blends chic boutiques, restaurants, and galleries with cobblestone streets, restored ships, and 18 museums. The Fulton Fish Market, a 200-year old testament to the site's unique history, continues to operate here as the largest fish market in the country. Stop by in the early morning for the freshest fish around.

The 350-foot-long "Peking" is the second-largest sailing ship ever built.

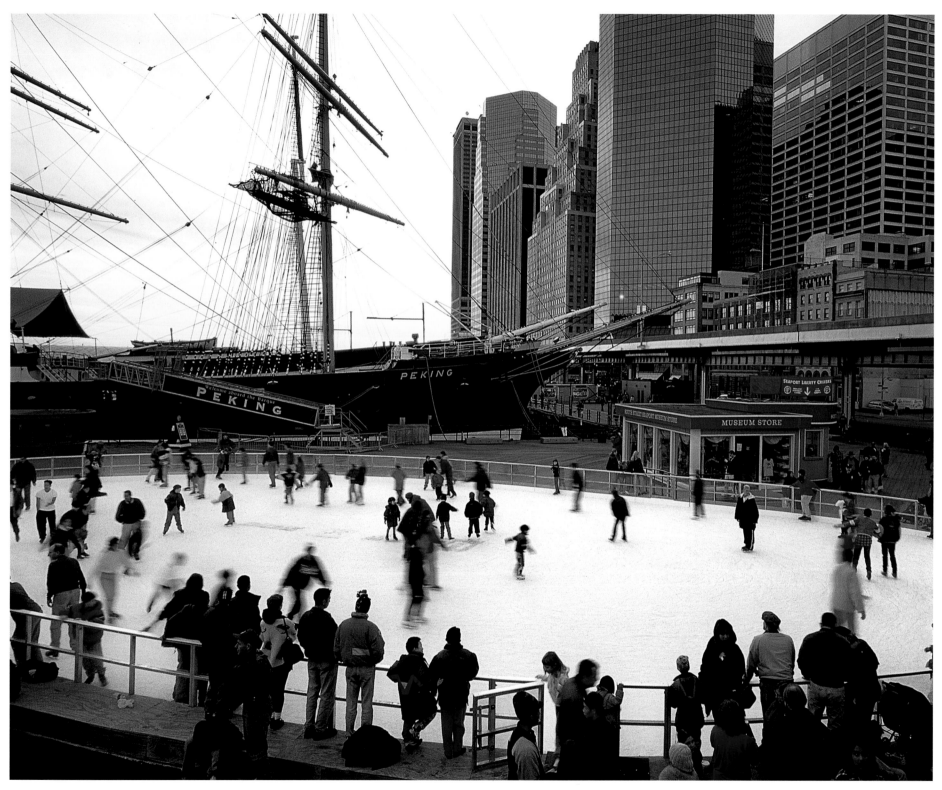

Skaters glide in the shadows of South Street Seaport's glorious past and present.

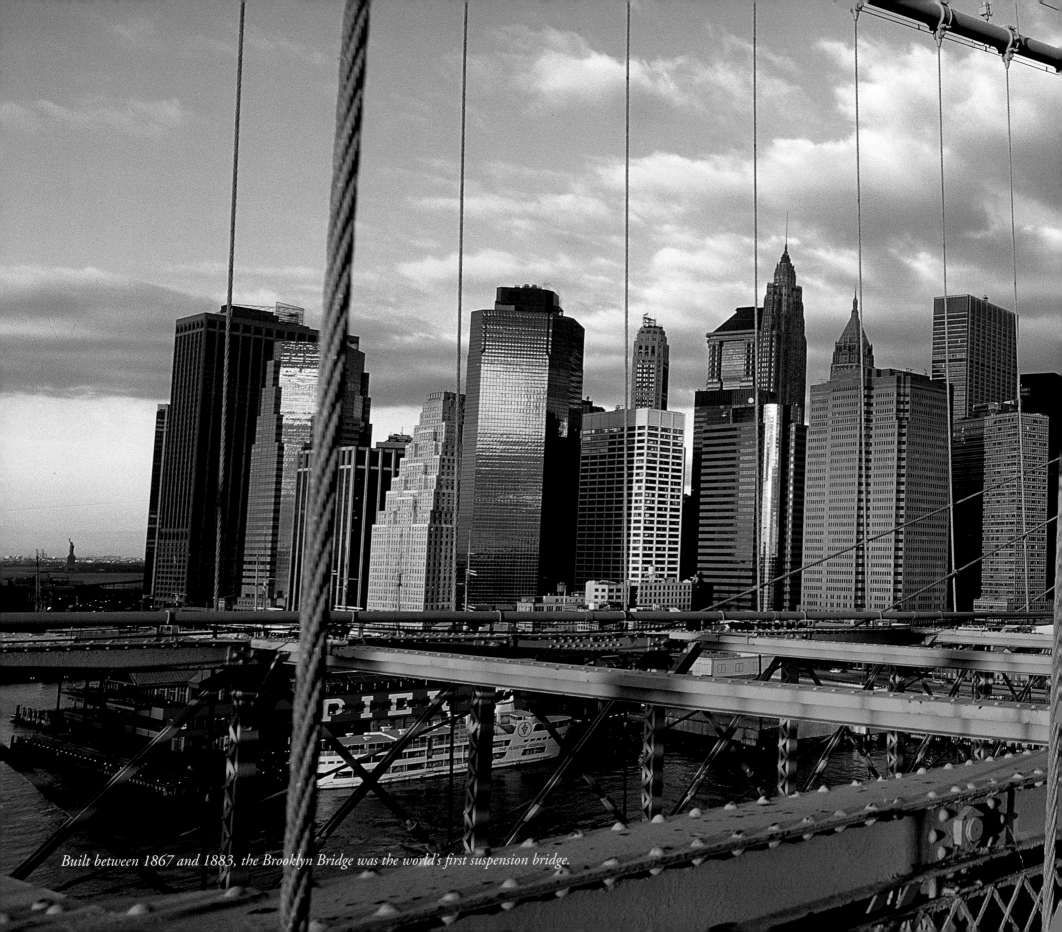

Built between 1867 and 1883, the Brooklyn Bridge was the world's first suspension bridge.

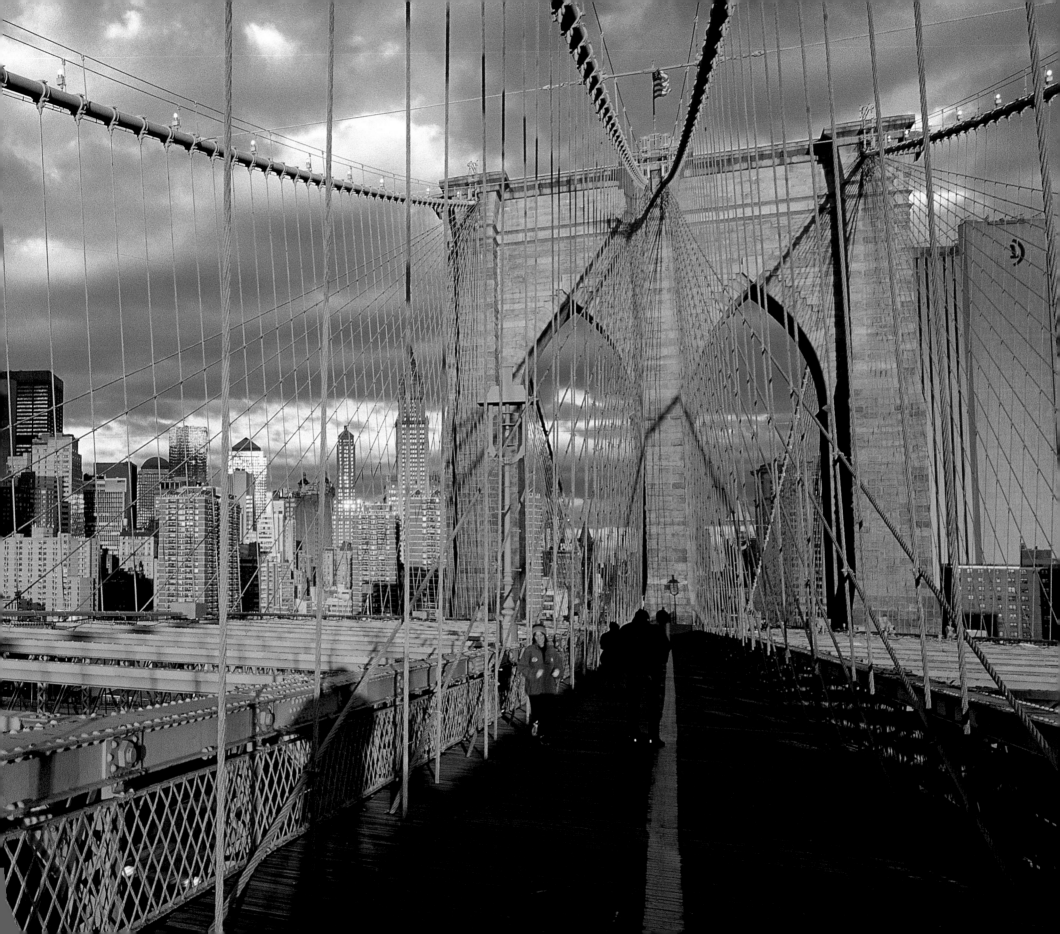

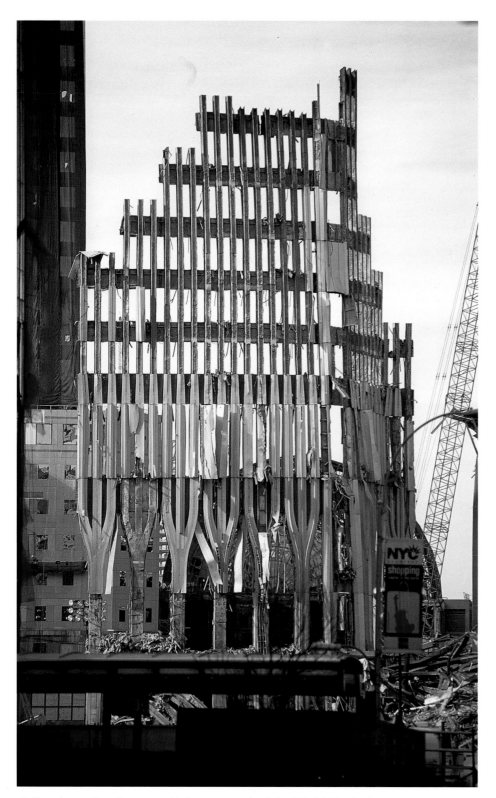

A few days after the event, little remained of the World Trade Center.

World Trade Center Site

"The number of casualties
may be more than any of us can bear."
— *Rudy Giuliani, mayor of New York, September 11, 2001*

Once there stood here the world's fifth and sixth largest buildings — the twin towers of the World Trade Center. Rising a quarter-mile tall, they defined the New York city skyline. No more. Today, the World Trade Center site is famous for another reason.

On September 11, 2001, at 8:46 a.m., a hijacked Boeing 767 plane was crashed into the north tower of New York City's World Trade Center. 16 minutes later, a second 767 plane crashed into the south tower. Both 110-story buildings were set ablaze with jet fuel and collapsed in less than two hours. Fortunately, about 16,000 people at the complex escaped but 2,749 people lost their lives.(+24 listed as mising)

It was the worst act of terrorism the world had seen. Lost were all 147 passengers and crew on both planes(plus the ten hijackers), all but 18 of the 1,966 people that were ar or above the floors where the planes hit, 343 firefighters. 60 police officers, and at least 10 bystanders on the ground.

Now the site is a memorial to those heroes. We shall never forget.

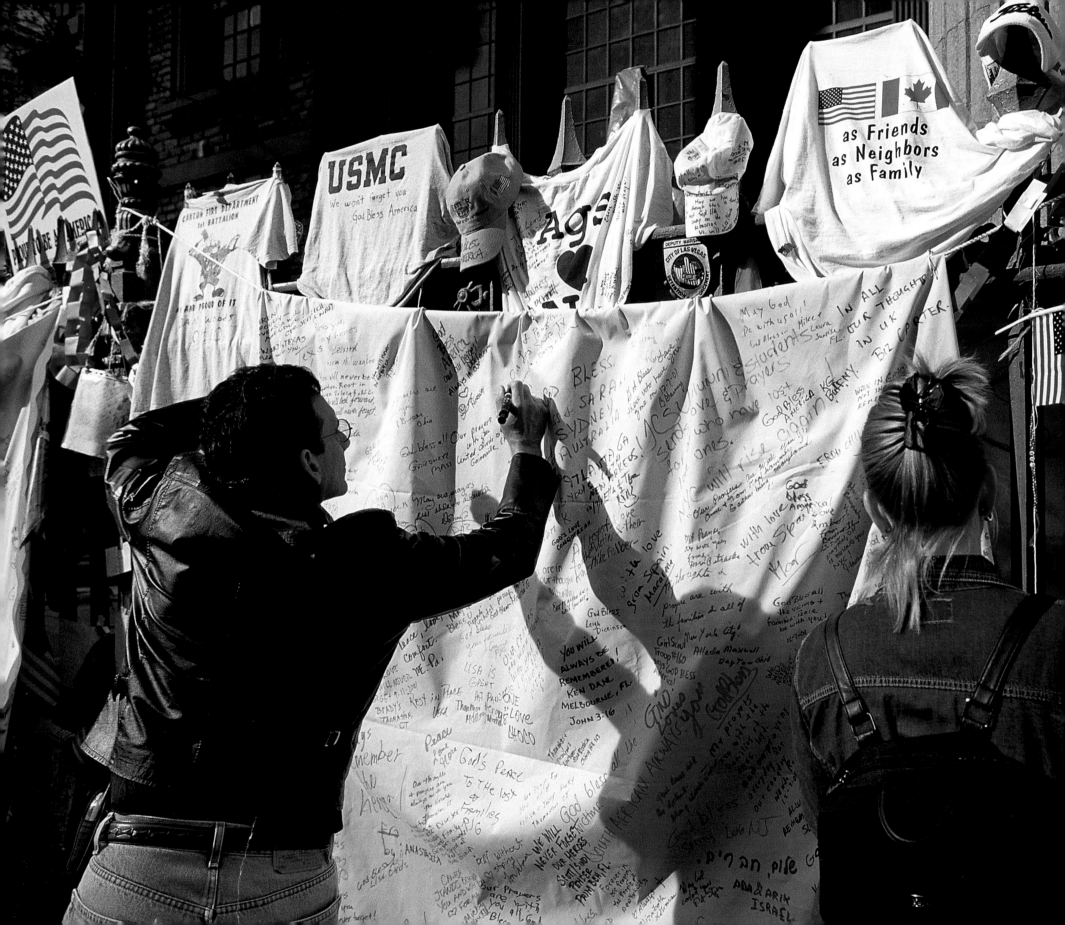

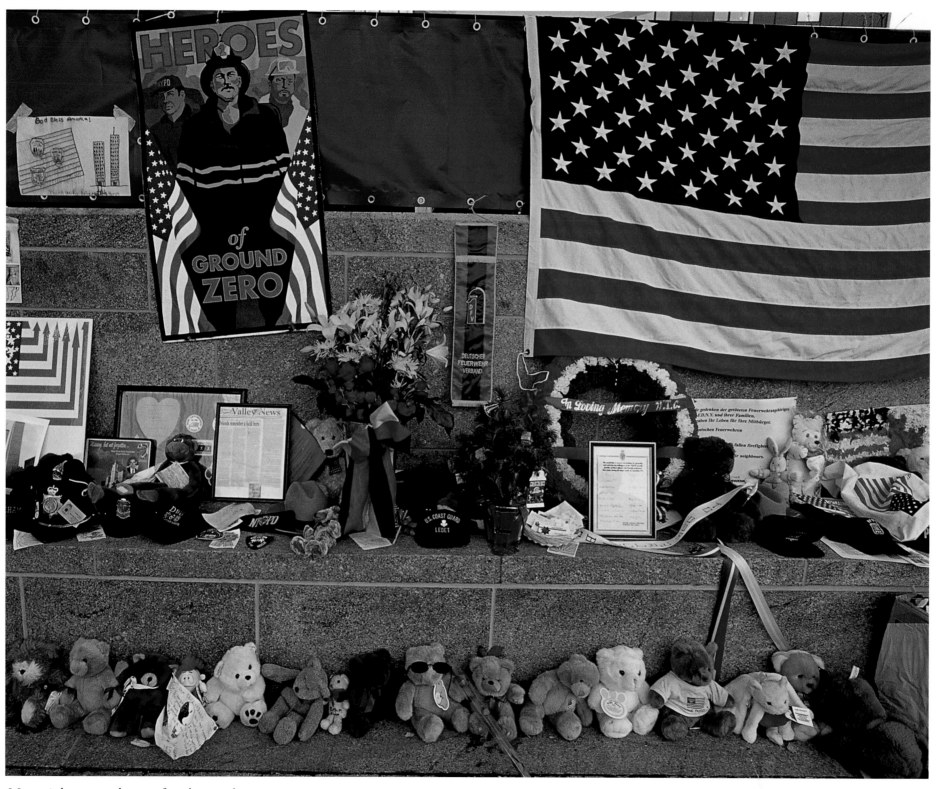

Memorials appeared soon after the attacks.

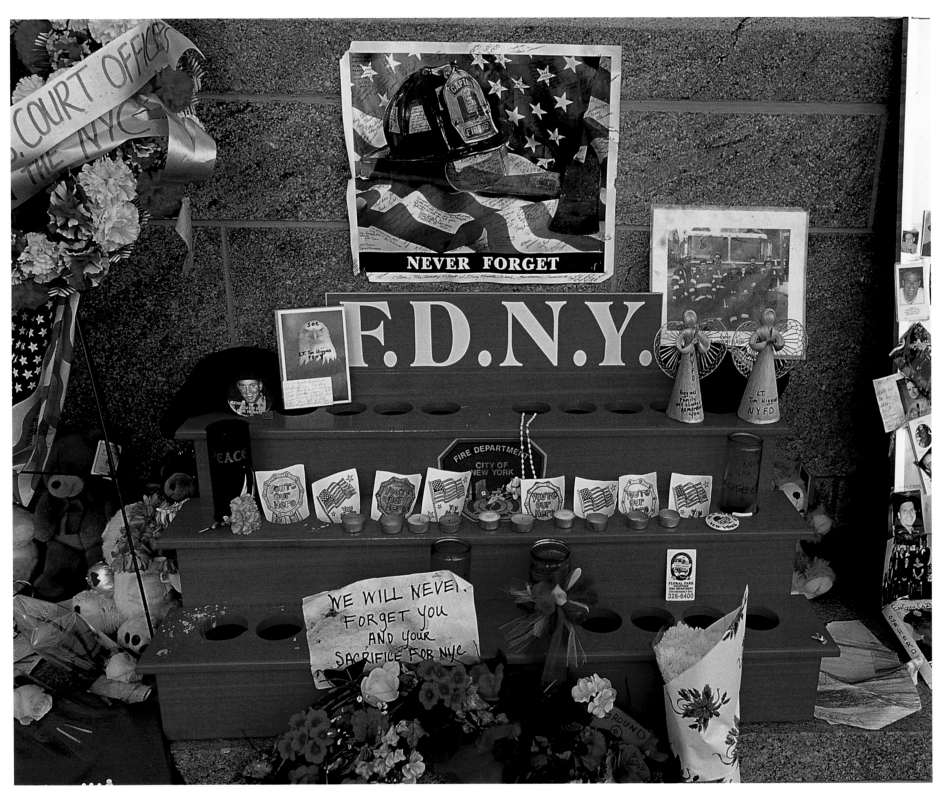

The Fire Department of New York lost many courageous people.

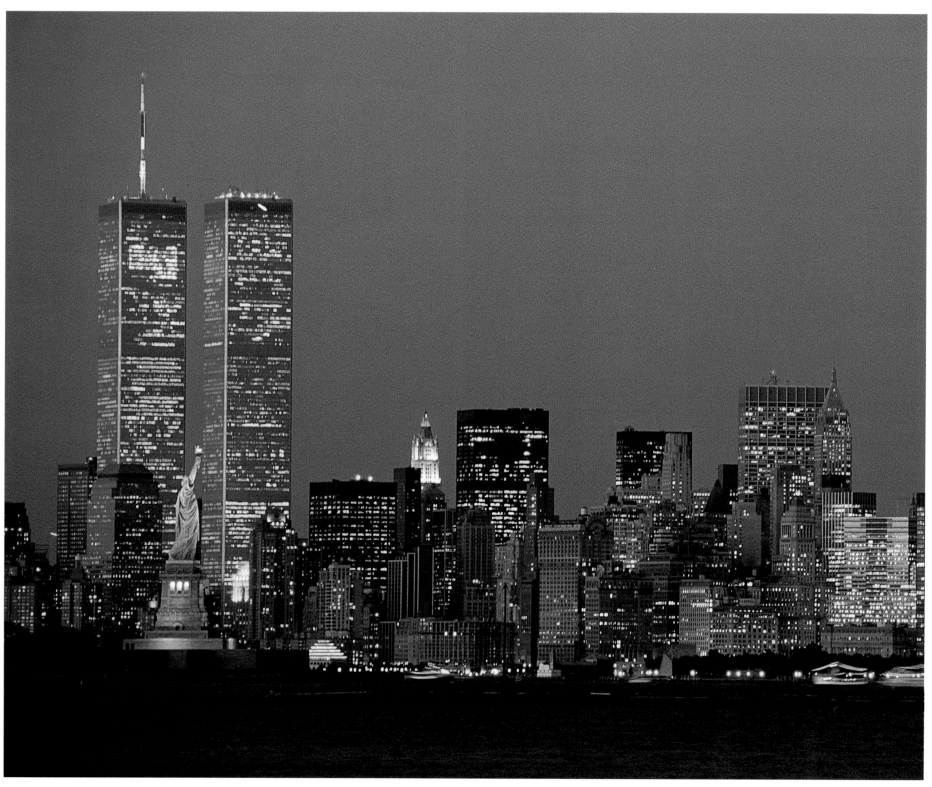

The New York city skyline before...

24

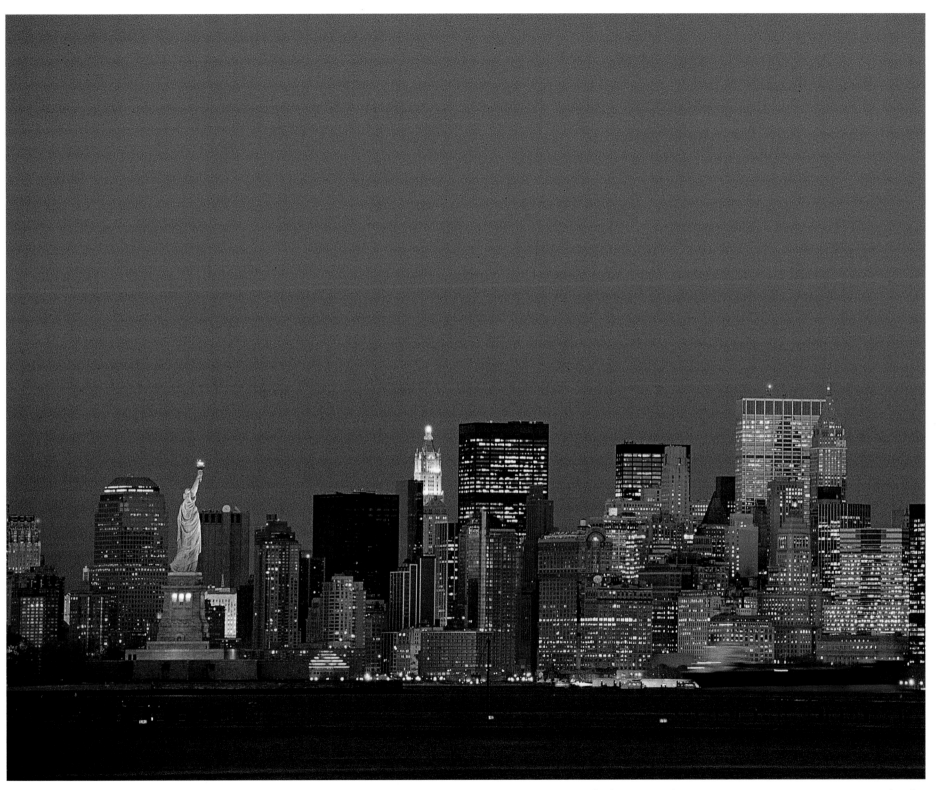

...and after September 11, 2001. Next page: How it used to be.

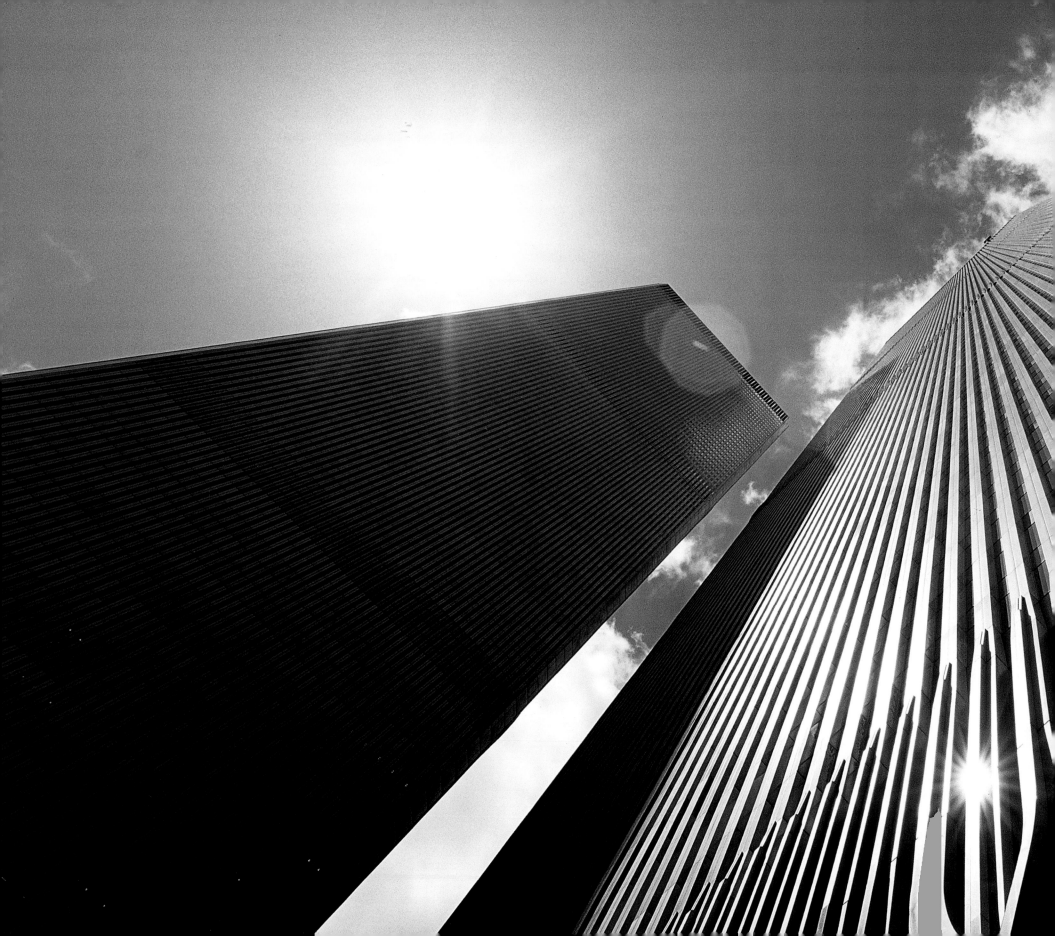

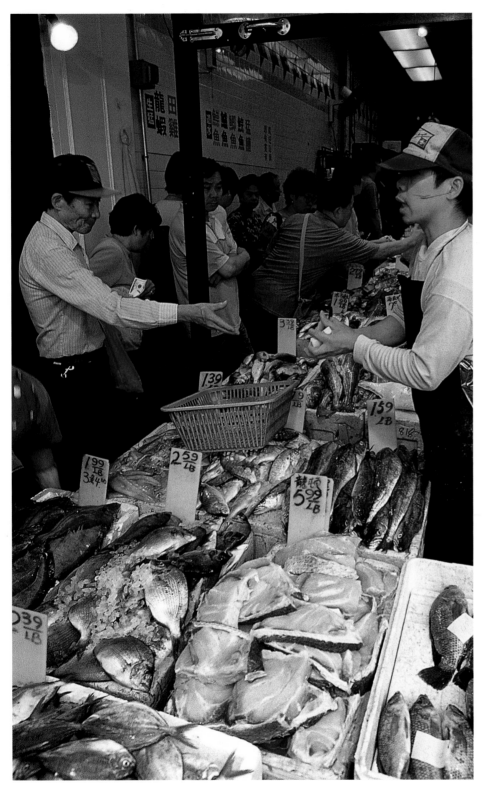

Business as usual for a busy fishmonger on Mott Street.

Chinatown

"In New York City, everyone is an exile,
none more so than the Americans."
— *Charlotte Perkins Gilman*

Manhattan's Chinatown is a crowded and bustling lower Manhattan neighborhood dripping with atmosphere, aroma, and Asian authenticity. For thousands of immigrants from Asian countries, it's a home-away-from-home.

The community got its start in the 1870s when Chinese railroad workers came east from California and settled. It now represents the largest Chinese community in the Western Hemisphere and a virtual melting pot within its own boundaries.

The neighborhood features more than 150,000 residents from China, Taiwan, Vietnam, Burma, Singapore, as well as far-flung places like Cuba and South America. Local enterprises include 600 factories, 350 restaurants, 27 banks, and 50 health spa/massage parlors.

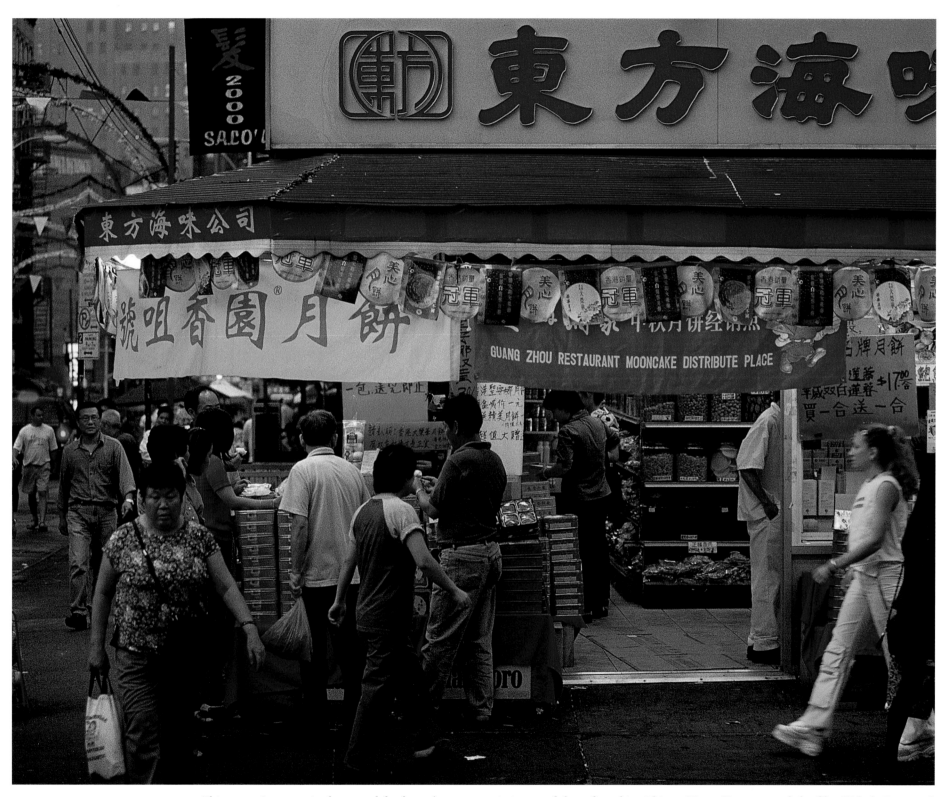

Chinatown's open-air shops and food markets are reminiscent of those found in China, Hong Kong ... and the film "Blade Runner."

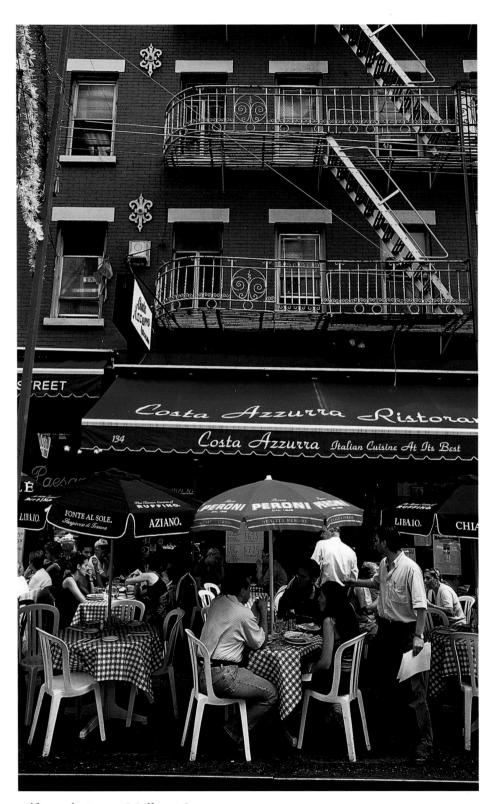

Little Italy

*"When the moon hits your eye
like a big pizza pie, that's amore."*
— Dean Martin

Sandwiched between Chinatown and Soho, this colorful neighborhood has gradually recreated itself from quaint old European charm to hip, trendy modernity. The area of Little Italy and Nolita, ("North of Little Italy"), boasts cool boutiques, cafes, and bars that belie its history as a 19th Century Italian enclave.

Authentic Little Italy businesses include Luna's restaurant — which has been operated by the same family since 1878 — and Umbertos Clam House — where the gangster Joey Gallo was gunned down in1972. The neighborhood, which has been awarded landmark status, annually celebrates in traditional Italian style the feasts of Saint Anthony in May and Saint Gennaro in September.

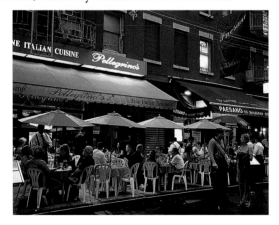

Alfresco dining on Mulberry Street.

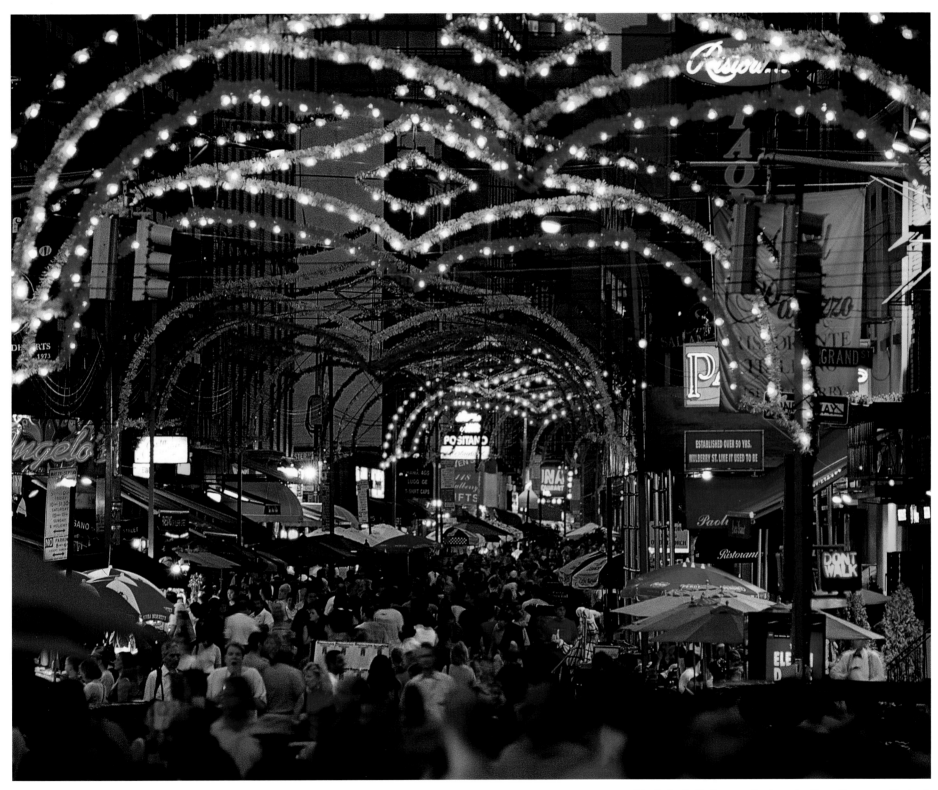

Little Italy lights up during the San Gennaro festival.

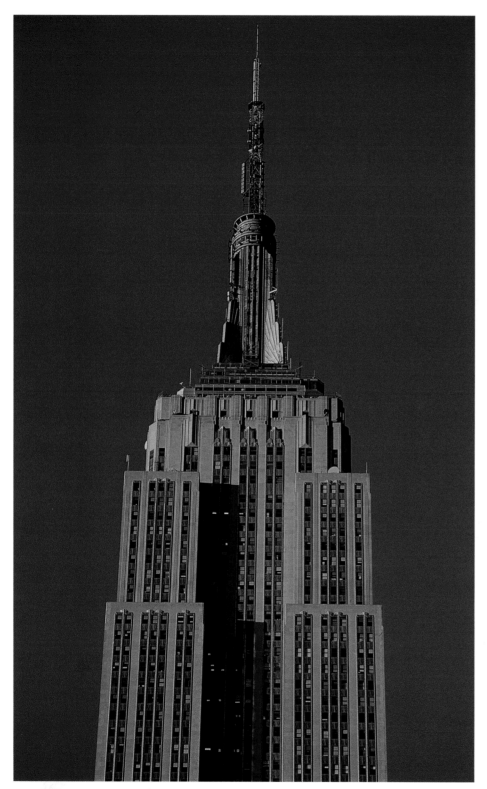

Empire State Building

"It's the nearest thing to heaven we have in New York."
— Deborah Kerr to Cary Grant in
"An Affair to Remember," 1957.

Gazing upon the Empire State Building, you might expect to see star-struck lovers Deborah Kerr and Cary Grant (*An Affair to Remember*, 1957), Meg Ryan and Tom Hanks (*Sleepless in Seattle*, 1993), or even King Kong and Fay Wray (*King Kong*, 1933).

Probably New York's most recognized building, this 102-story monument reigned as the tallest building in the world from its completion in 1931 until 1970. During the early years, just after the Depression, so few businesses could afford office space that it was dubbed the "Empty State Building,"only the observatories kept it solvent.

Today, there are occupants behind each one of the 6,500 windows that line the 1,250-foot high structure. Of course, the observatories — which are serviced by fast elevators that travel 1,200 feet per minute — are as popular as ever.

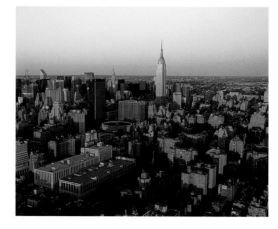

The Empire State Building is made from 10 million bricks.

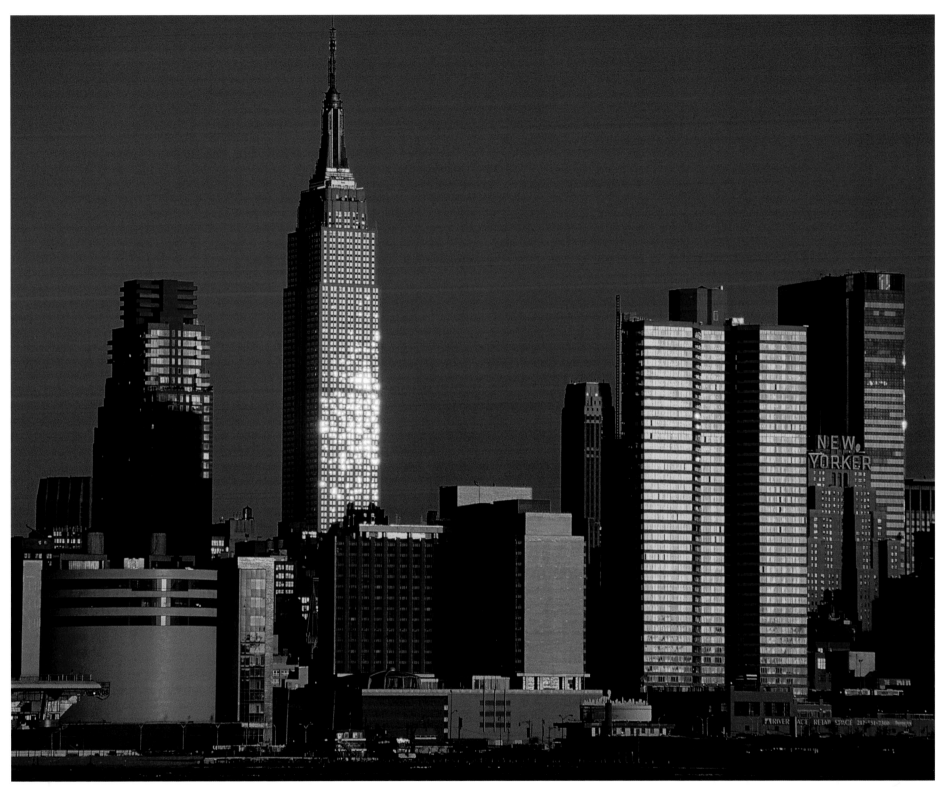

The mid-Manhattan skyline glows in the late afternoon sun.

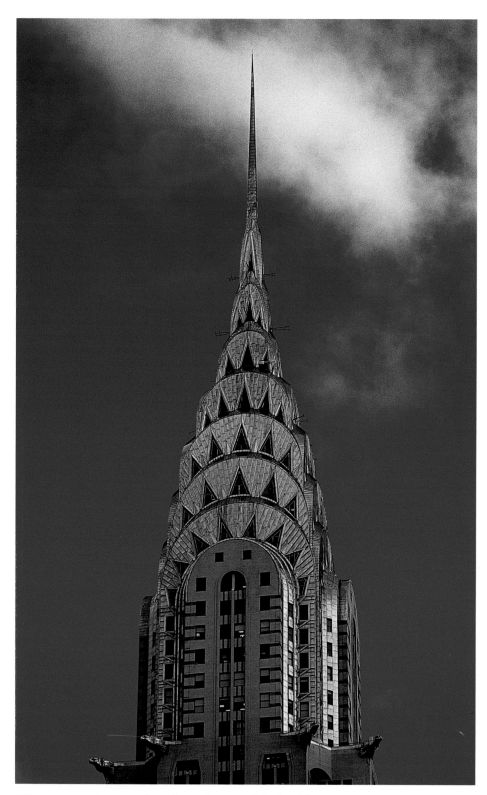

The spire reaches 123 feet above the rest of the building.

Chrysler Building

"Make this building higher than the Eiffel Tower."
— Walter Chrysler to architect William Van Alen.

Possibly the world's most beautiful skyscraper, this Art Deco masterpiece reigned briefly as the world's tallest building when it opened in 1930.

Commissioned by automobile mogul Walter Chrysler, the 77-story Chrysler Building incorporates designs from cars. The distinctive spire, made of stainless steel, is modeled after the radiator grill of a 1929 Chrysler Plymouth automobile. The winged steel gargoyles are based on the car's radiator cap, and there are details of hubcaps and car radiators on other sections. The lobby features chrome interiors and a 100-foot long mural celebrating transportation.

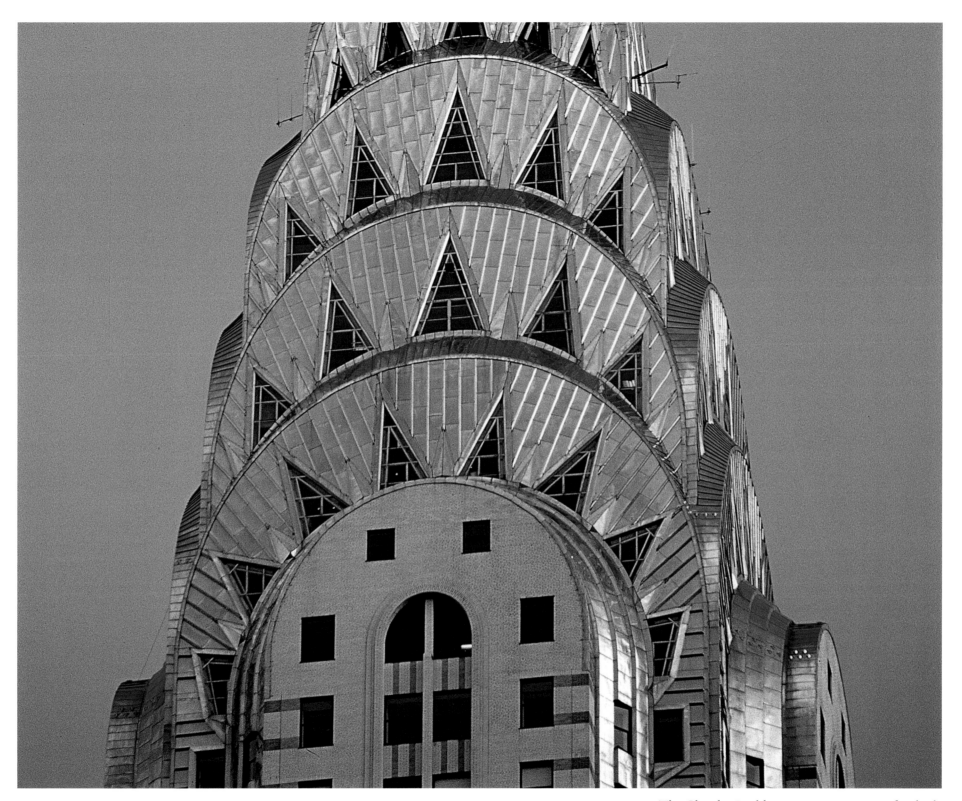

The Chrysler Building towers over 1,000 feet high.

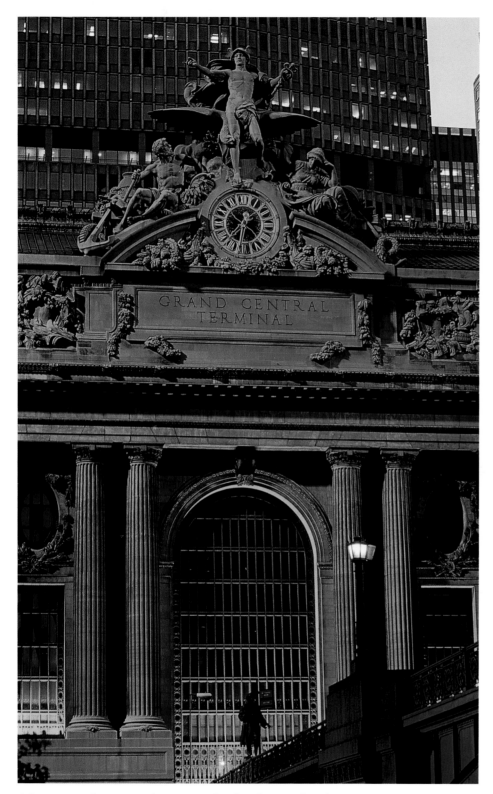

The statue of Mercury dominates the 42nd Street facade.

Grand Central Terminal

"Start spreading the news, I'm leaving today,
I want to be a part of it, New York, New York."
— Frank Sinatra, "New York, New York."

Opened in 1913, this Beaux-Arts masterpiece was modeled, in part, after the Paris Opera. It is the hub of the Metro North commuter train lines reaching out into Connecticut and Westchester County.

Grand Central Terminal is used by almost half a million passengers a day, who arrive and depart on more than 550 trains. The Terminal was declared a National Monument in 1976, which effectively derailed a proposal to replace it with an office building. On the building's facade, above the clock, is a figure of Mercury, described by sculptor Jules-Felix Coutan as "the god of speed, or traffic, and of the transmission of intelligence."

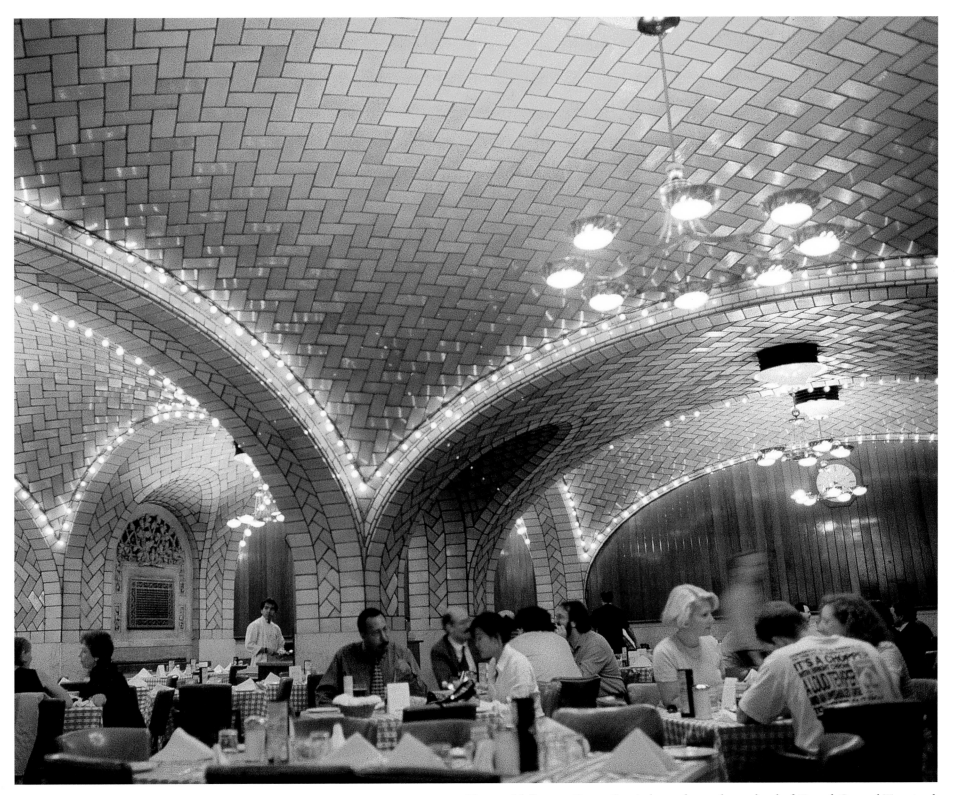

The world-famous Oyster Bar is located on a lower level of Grand Central Terminal.

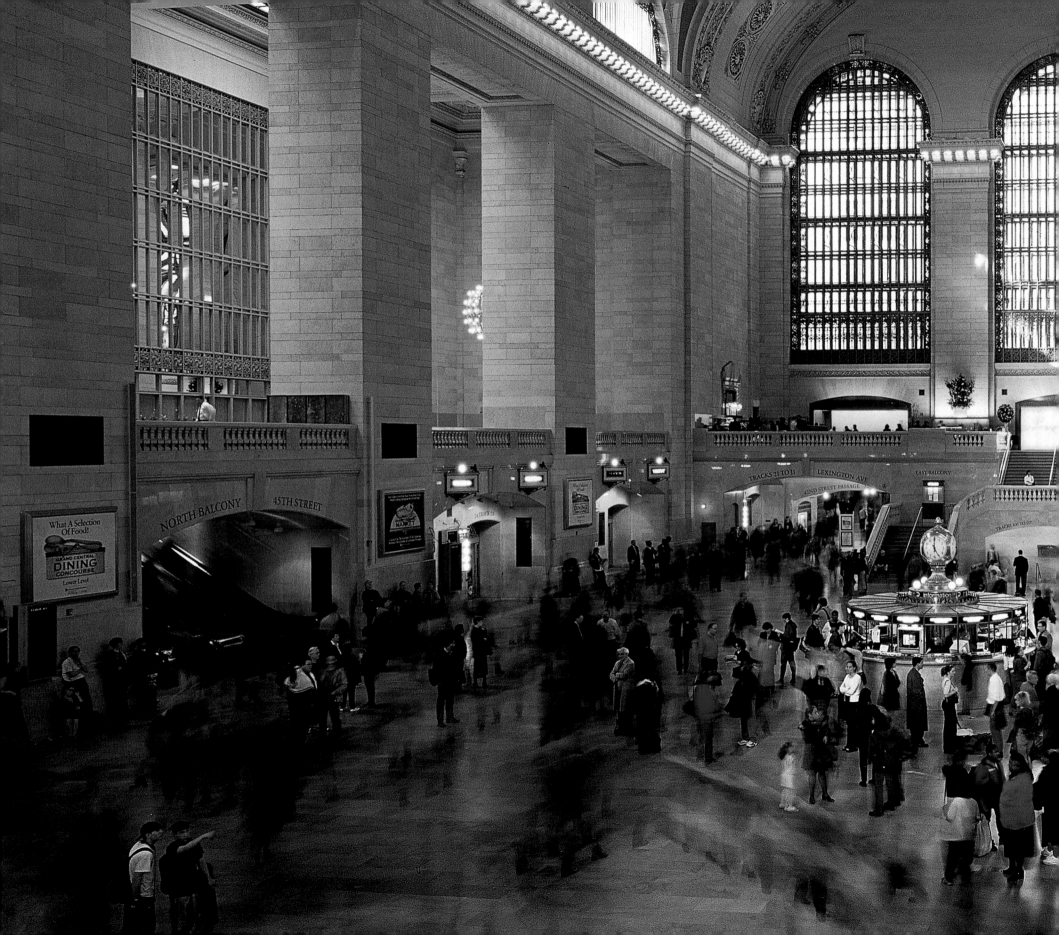

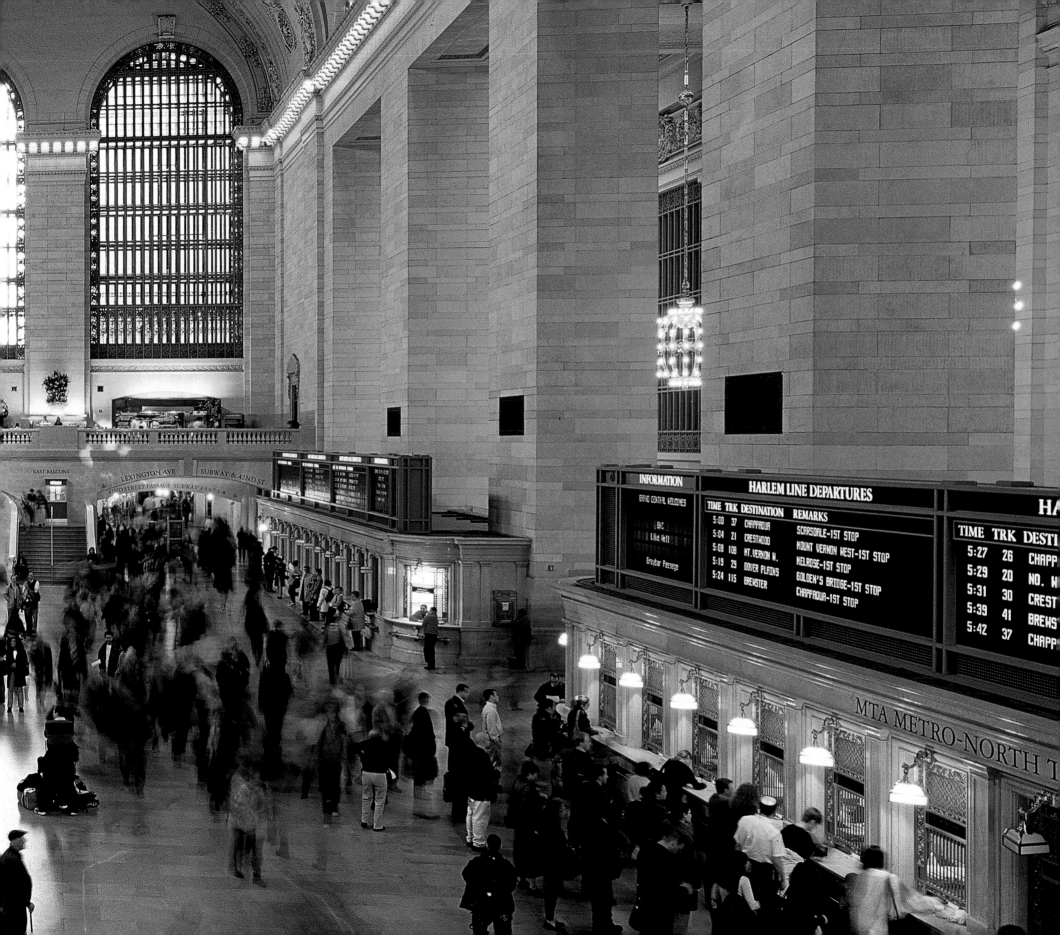

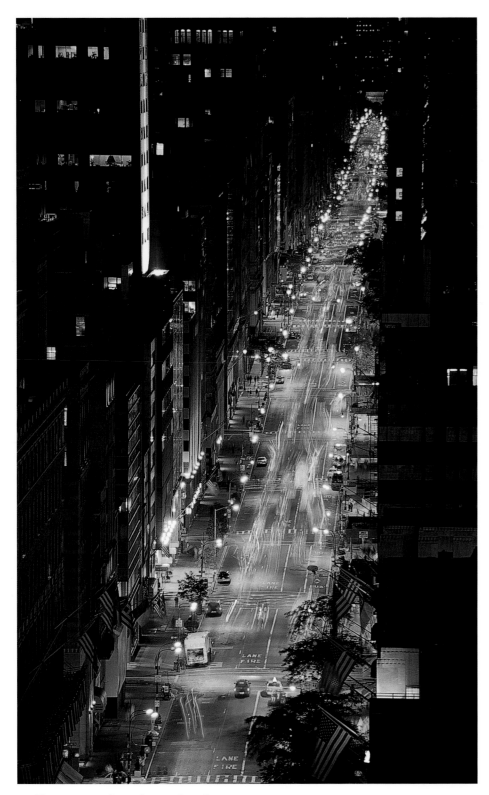

Fifth Avenue is busy day and night.

Fifth Avenue

"Is New York such a labyrinth? I thought it was all straight up and down like Fifth Avenue. All the cross streets numbered and big honest labels on everything."
— Ellen Olenska,
from "The Age of Innocence" by Edith Wharton.

Few streets capture the essence of a city — and the imagination of the world — more thoroughly than Fifth Avenue in New York City. The 132-block thoroughfare runs almost the full thirteen-mile-length of Manhattan, dividing the island in half between east and west.

Fifth Avenue is known as the place where New York City displays its treasures. Whether it is the cultural cornucopia of the Museum Mile; the architectural gems like the Empire State Building, the New York Public Library, and St. Patrick's Cathedral; or the elegant shops like Saks, Lord & Taylor, Cartier, and Tiffany & Co., Fifth Avenue is home to all the best New York has to offer. Poet Ezra Pound called the signs in Times Square "our poetry, for we have pulled the stars down to our own will."

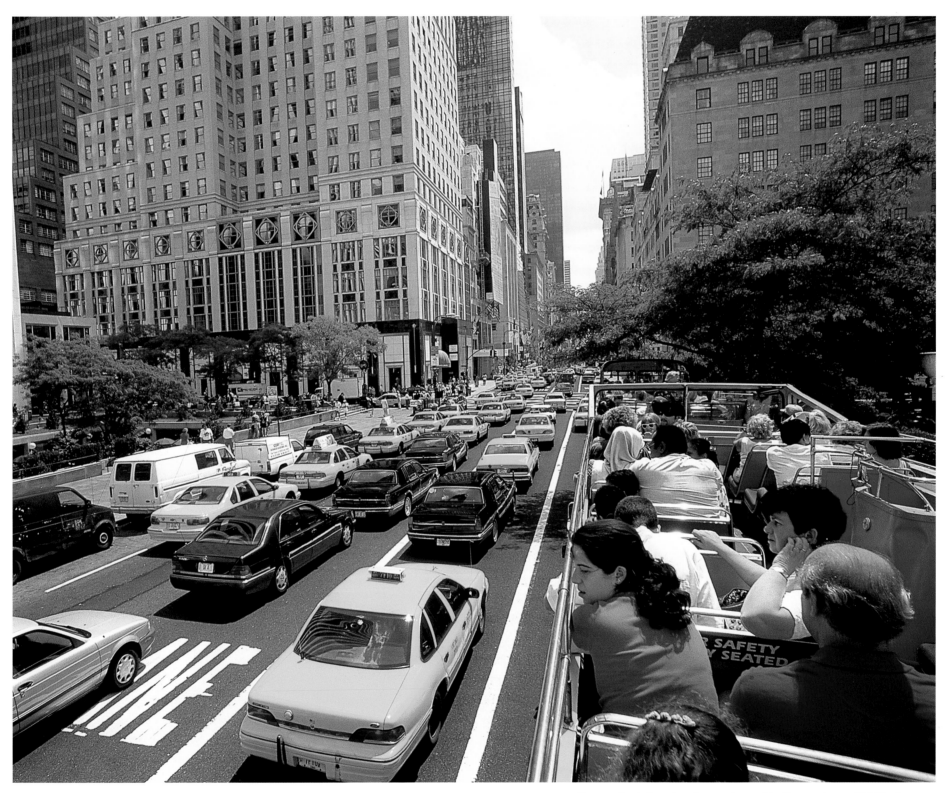

Open-air sightseeing buses give a bird's eye view of Fifth Avenue.

The sights of Fifth Avenue.

42

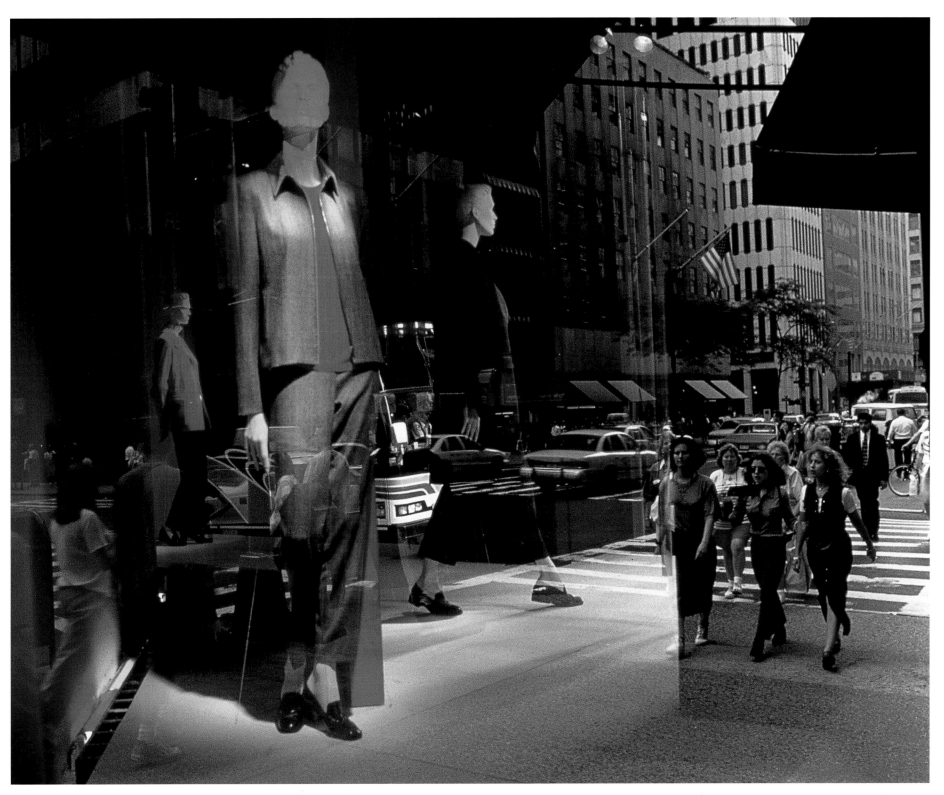

Mannequins in Saks Fifth Avenue seem to emulate the stride of passing pedestrians.

43

Enjoying Washington Square.

44

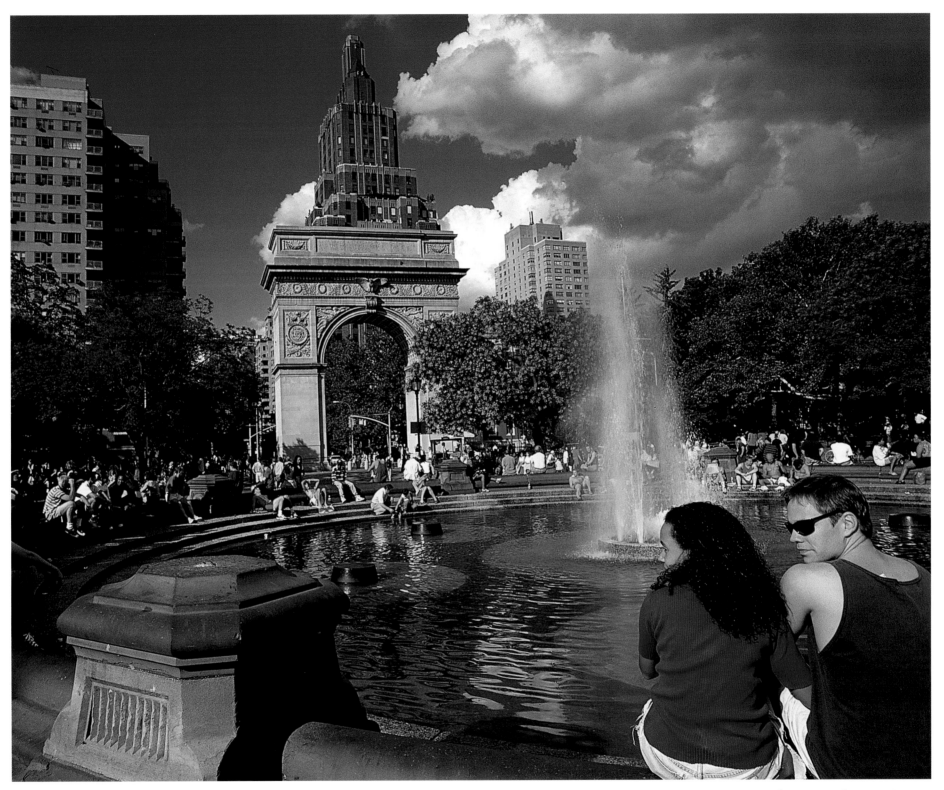

A rainbow in Washington Square.

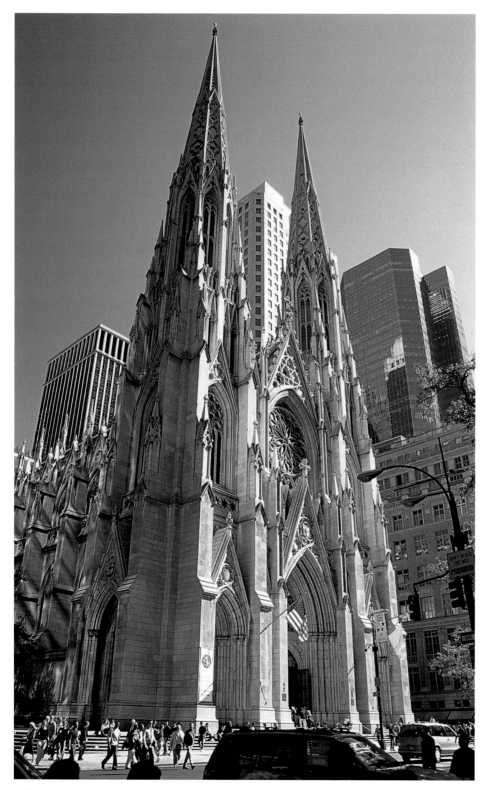

The facade of Saint Patrick's Cathedral.

Saint Patrick's Cathedral

"City of hurried and sparkling waters!
City of spires and masts!
City nested in bays!
My city!"
—*Walt Whitman*

This Gothic-Revival cathedral has it all, including an exquisitely ornate exterior, a crypt, and an altar designed by a famous New York jeweler Tiffany & Co. Seat of the Archdiocese of New York, St. Patrick's Cathedral is the largest Catholic Church in the United States. Its gothic twin spires reach 330-feet from street level to compete with the sleek angles of the surrounding skyscrapers.

The cathedral serves as the resting place for all the Archbishops of New York, who are buried in a crypt under the high altar. Their honorary hats, called *galeros*, hang from the ceiling over their tombs.

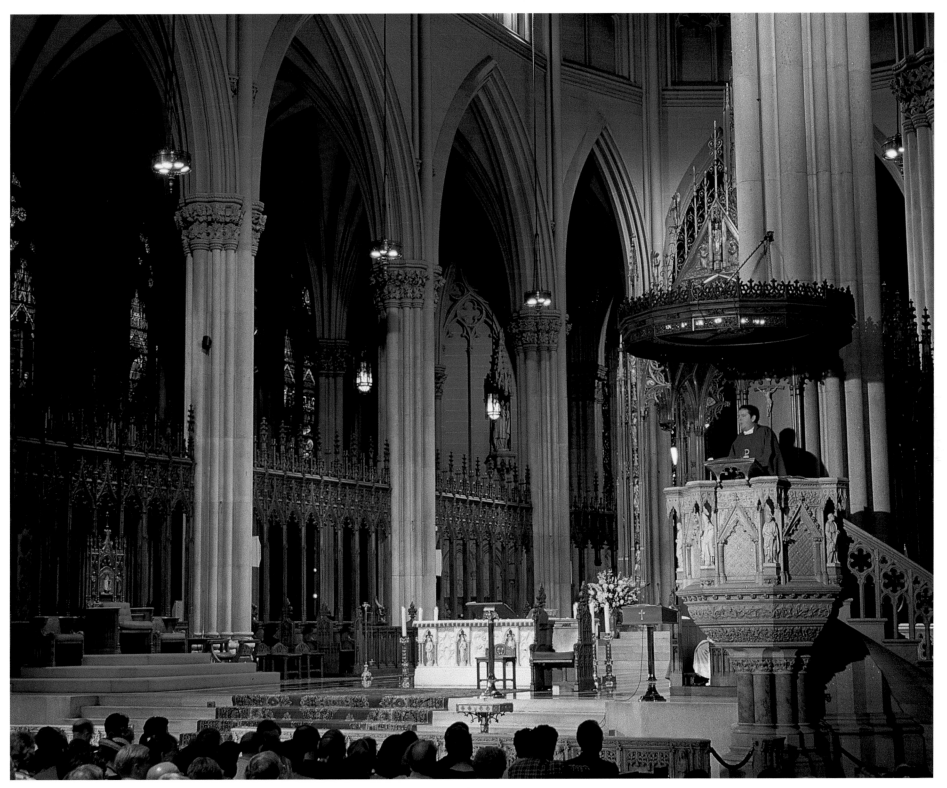

A Sunday service in Saint Patrick's Cathedral.

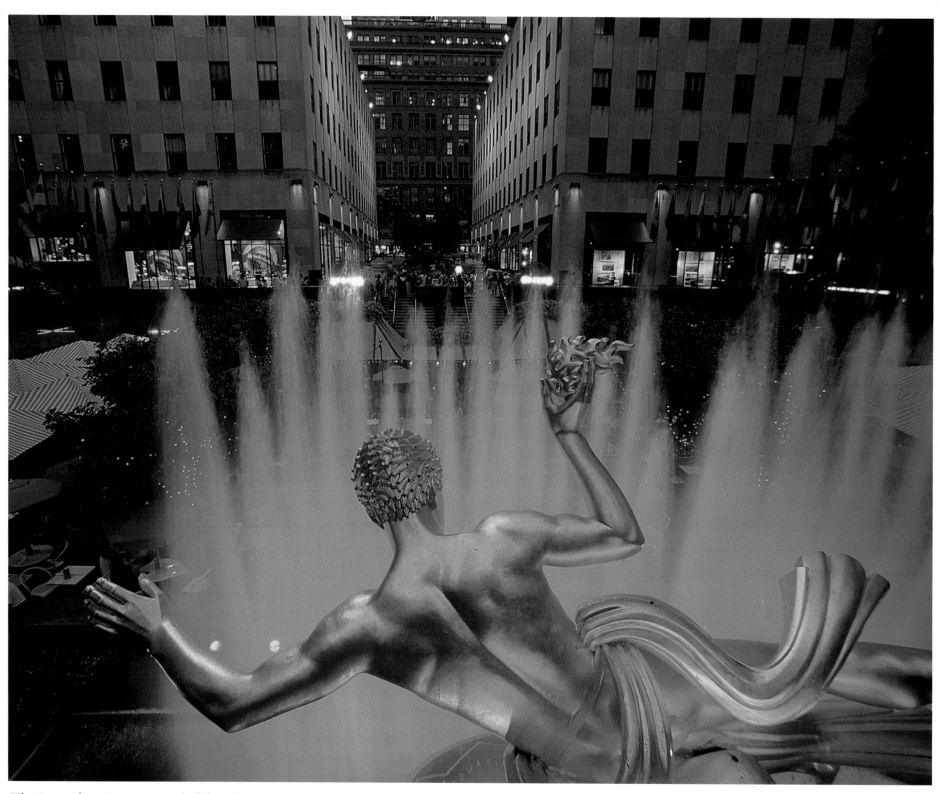

The Prometheus Statue in Rockefeller Plaza is 18 feet long and made of bronze.

Rockefeller Center

"The view of Rockefeller Center from Fifth Avenue is the most beautiful I have ever seen."
— *Gertrude Stein*

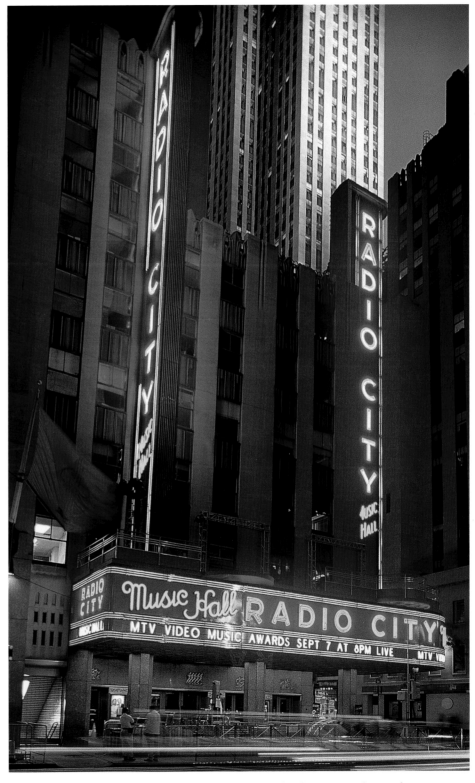

Recognize this place from TV? If you watch NBC's "Today" show you will recall seeing excited fans filmed outside the ground floor studio at Rockefeller Center.

Home to NBC Television, the 19-building, 22-acre Art Deco complex — called the "heart of New York" by the Landmarks Commission — was the brainchild of John D. Rockefeller Jr. With unfortunate timing, Rockefeller announced the architect for the complex the same day that the stock market crashed. During the resulting Depression, the construction of the center provided jobs for a quarter of a million workers.

Rockefeller Center is known for three quintessential New York experiences: ice skating under the watchful eye of the Prometheus statue; enjoying the view of the huge Christmas tree from a bench in the Channel Gardens; and taking in the holiday shows at Radio City Music Hall.

Radio City Music Hall is home to the famous Rockettes dance troupe.

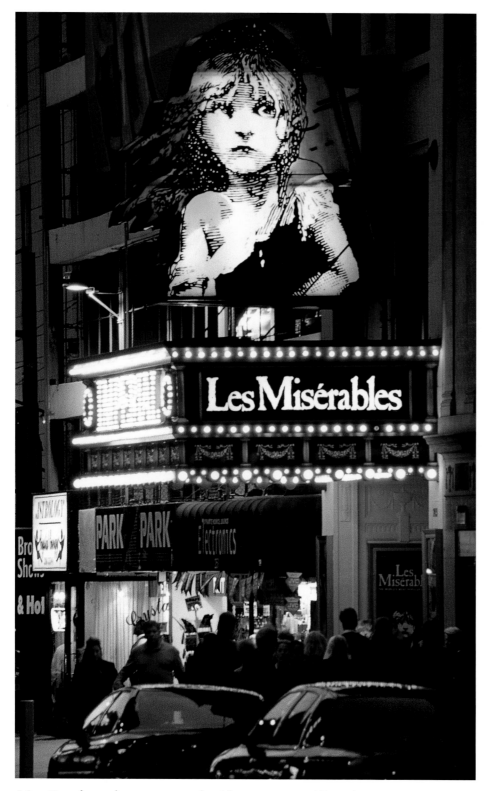

Most Broadway theaters are on the side streets around Broadway.

Broadway

"They say the neon lights are bright on Broadway,
They say there's always magic in the air."
— From "On Broadway", by Mann/Weil/Leiber/Stoller

Broadway: **The name calls up visions of bright lights,** dancing, music, champagne, and of stars made and lost. Called the "Great White Way" in the early 1900s for its electric street signs and 50-plus theaters, the term "Broadway" now encompasses the entire theater district around Times Square and 42nd Street. There are about 38 "Broadway" theaters, but only four — the Broadway Theater, the Marquis, the Palace, and the Winter Garden — are actually on Broadway itself.

More than 11 million people a year take in shows in the Broadway theater district, bringing in over half a billion dollars of income for show producers. But the competition is fierce and for every long running hit — in 2000, "Cats" closed after a record 18 years — there are countless short-lived shows.

While the area is known for the big shows at the "Broadway" theaters, there are many more smaller shows at the over one hundred "off-Broadway" and even "off-off-Broadway" theaters.

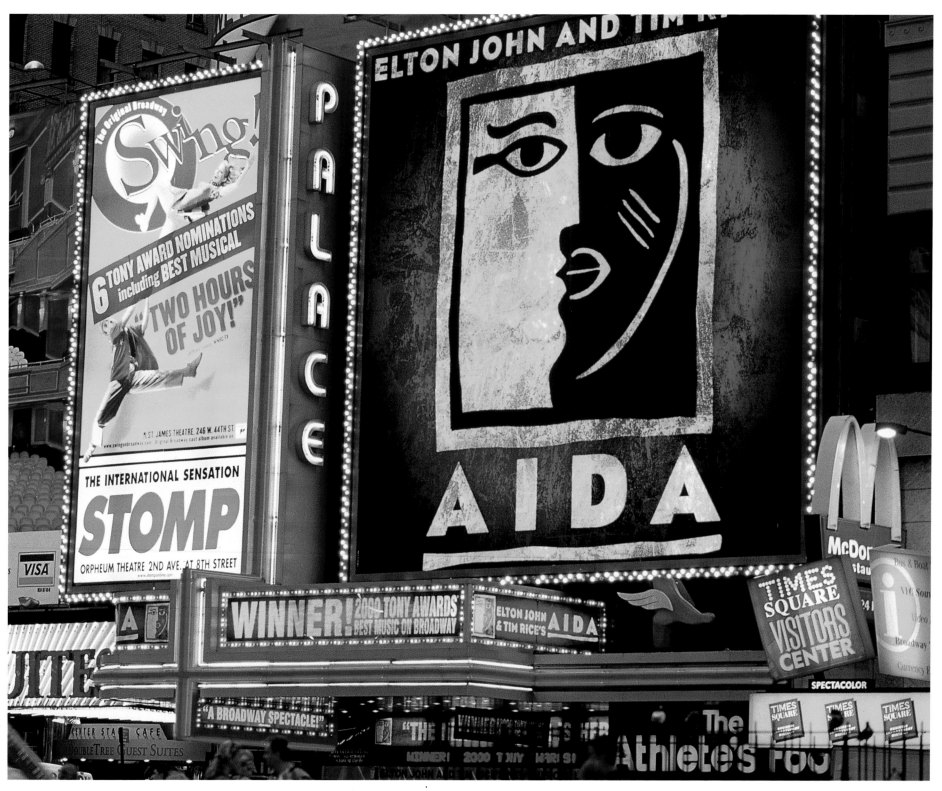

Colorful marquees along Broadway.

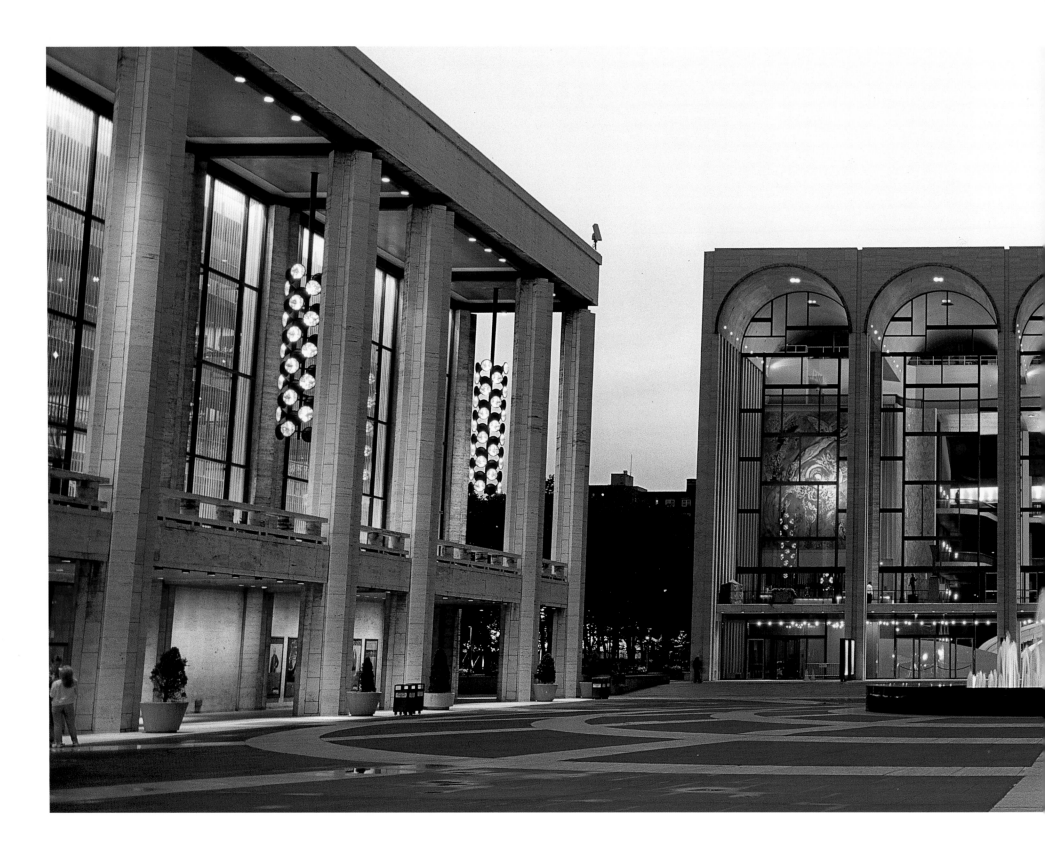

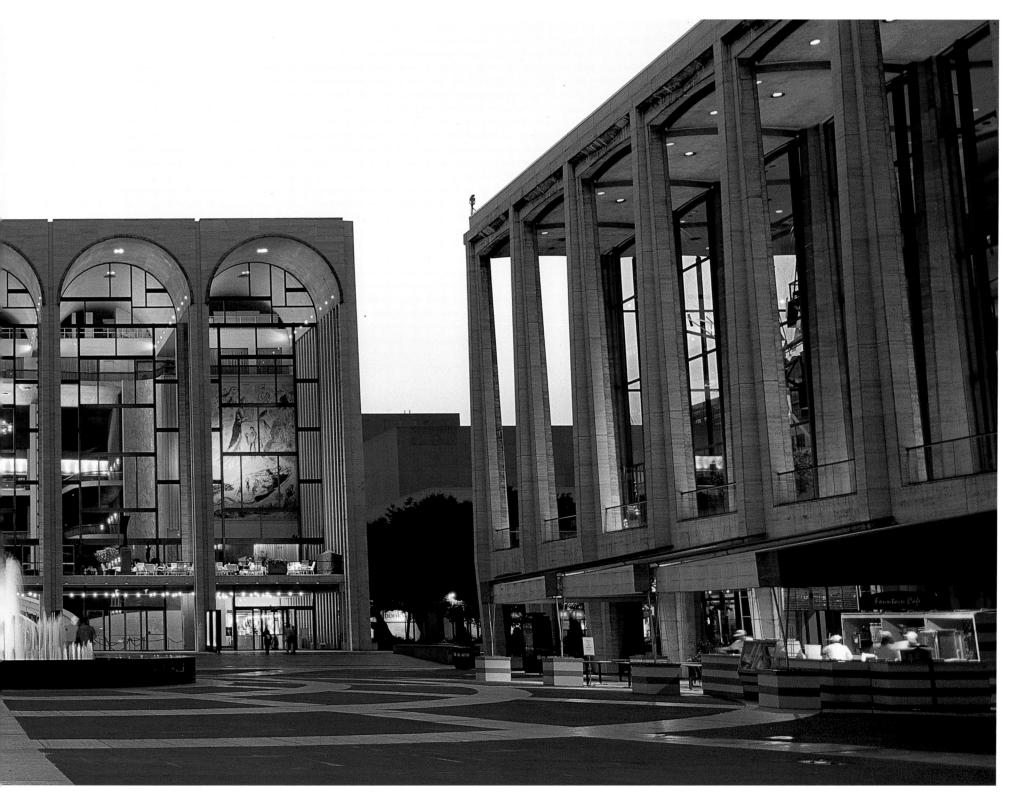

Lincoln Center is home to the New York City Opera, the New York Philharmonic Orchestra, and the New York City Ballet.

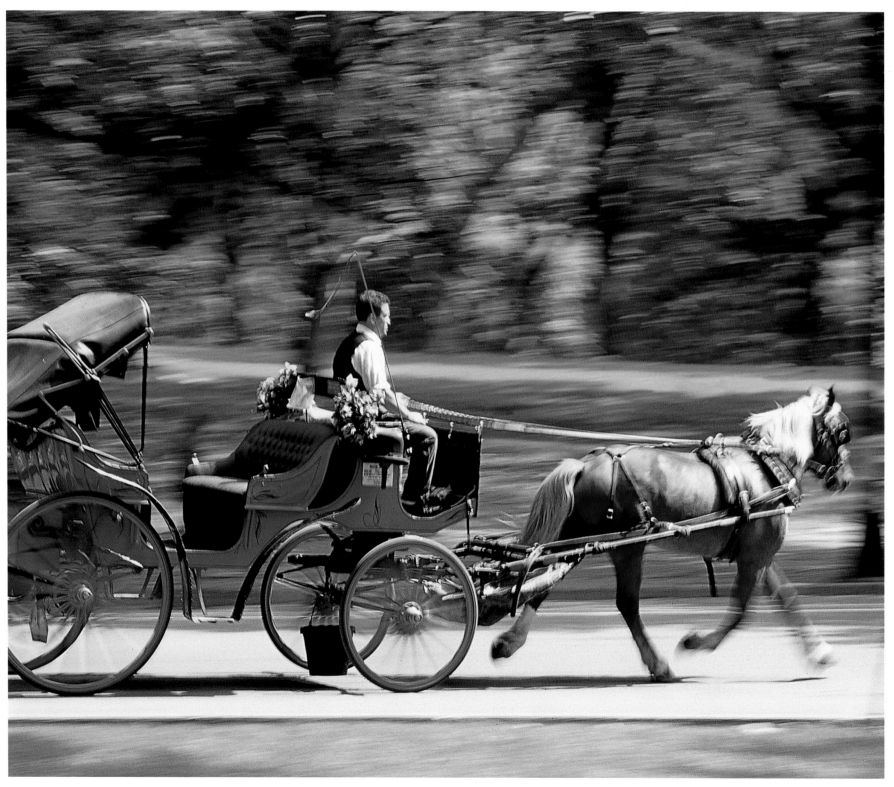

Riding in a horse-drawn carriage is a relaxing way to see Central Park.

Central Park

*"The non-building that could well lay claim to being
New York's greatest work of architecture."*
— Paul Goldberger, critic

Originally an unwanted stretch of granite quarries, illegal distilleries, and pig farms, Central Park is now an 843-acre oasis for New Yorkers to relax, slow down, and smell the roses. Bordered by Central Park West and Fifth Avenue, Central Park stretches 2-½ miles from 59th Street to 110th Street. Its facilities include 22 playgrounds, 26 baseball diamonds, 30 tennis courts, countless miles of jogging and bridle paths, a zoo, a theater, and even a castle.

A hackney driver evokes the look of a bygone era.

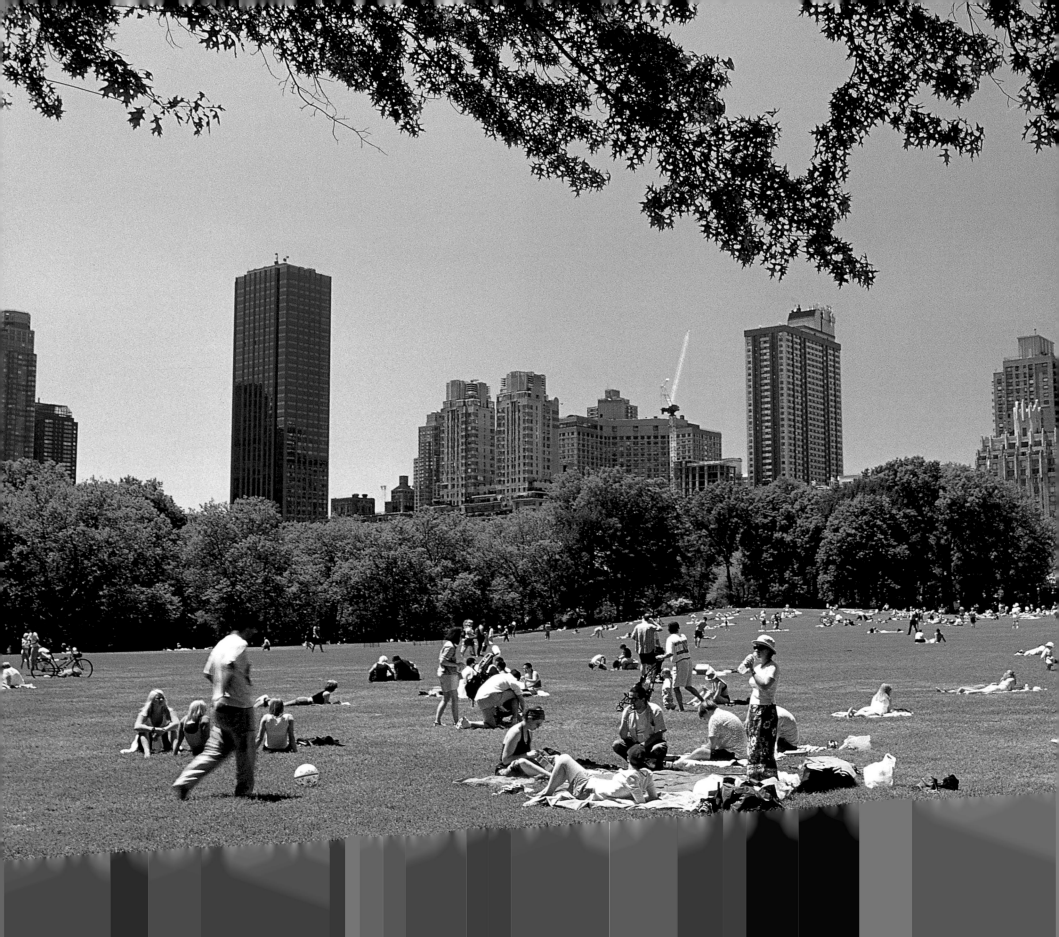

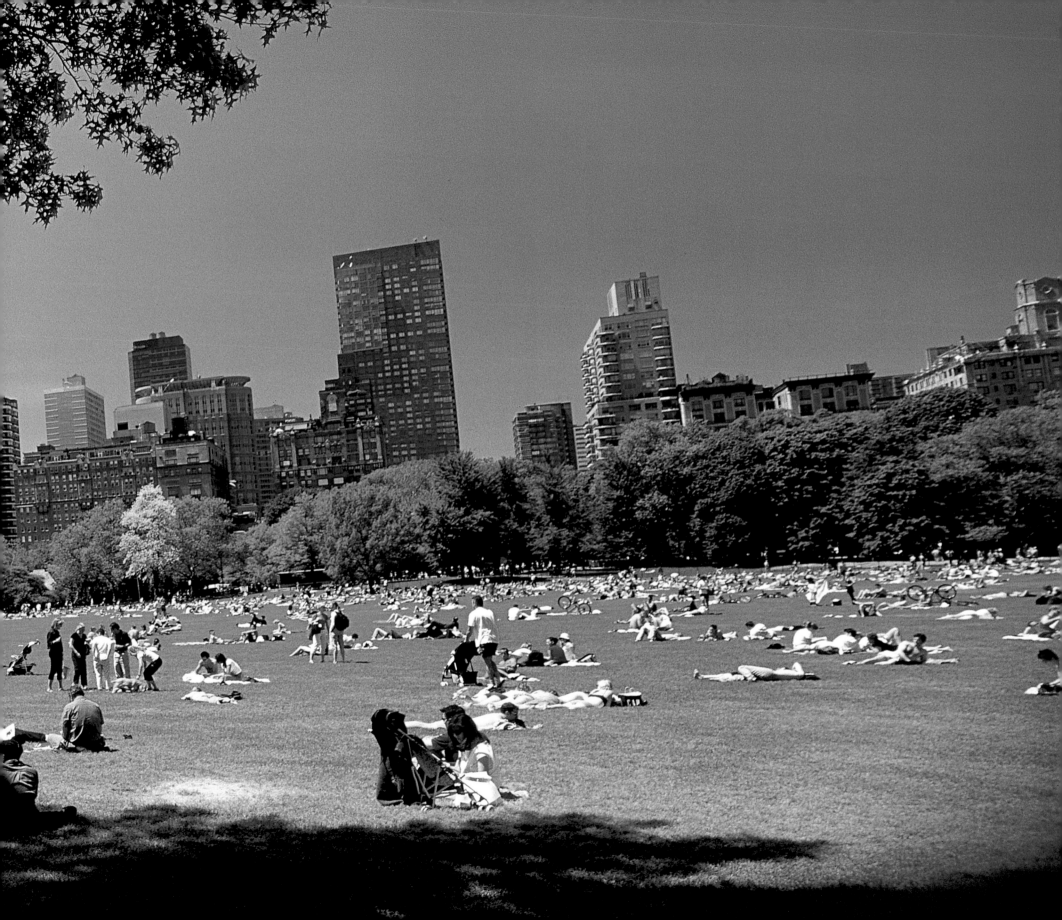

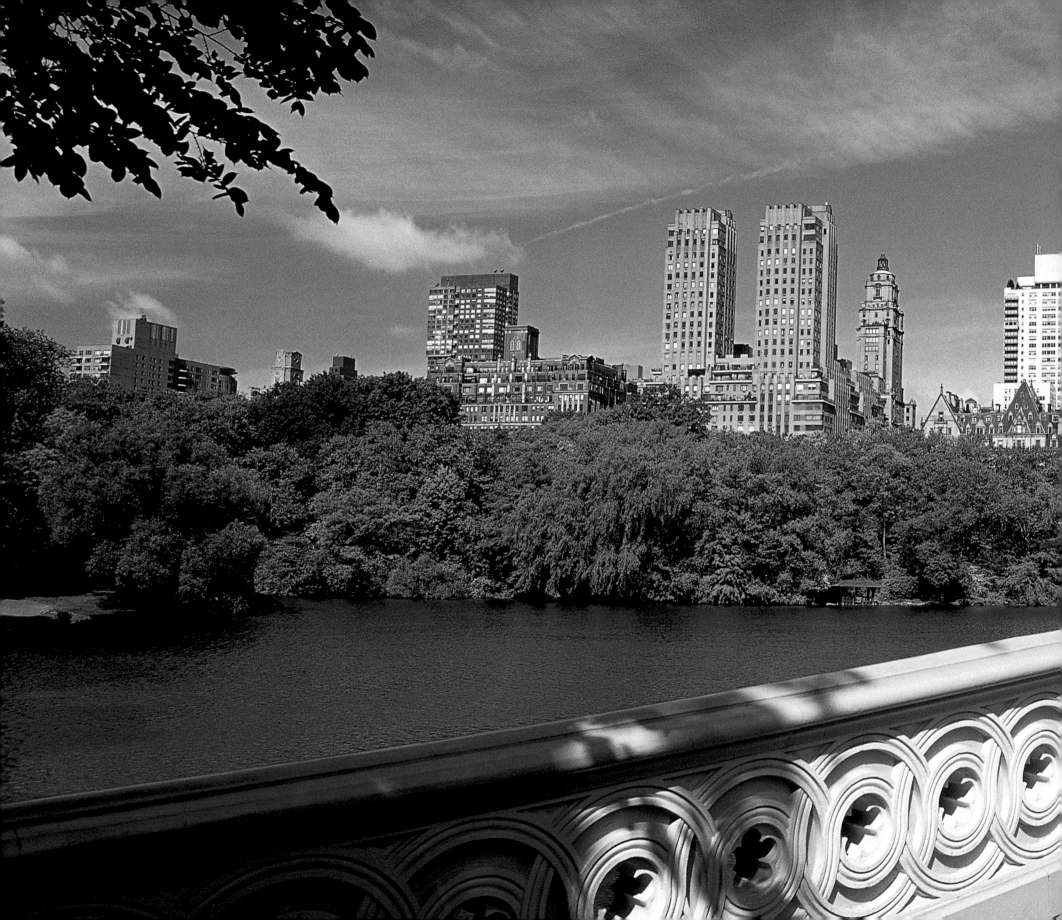

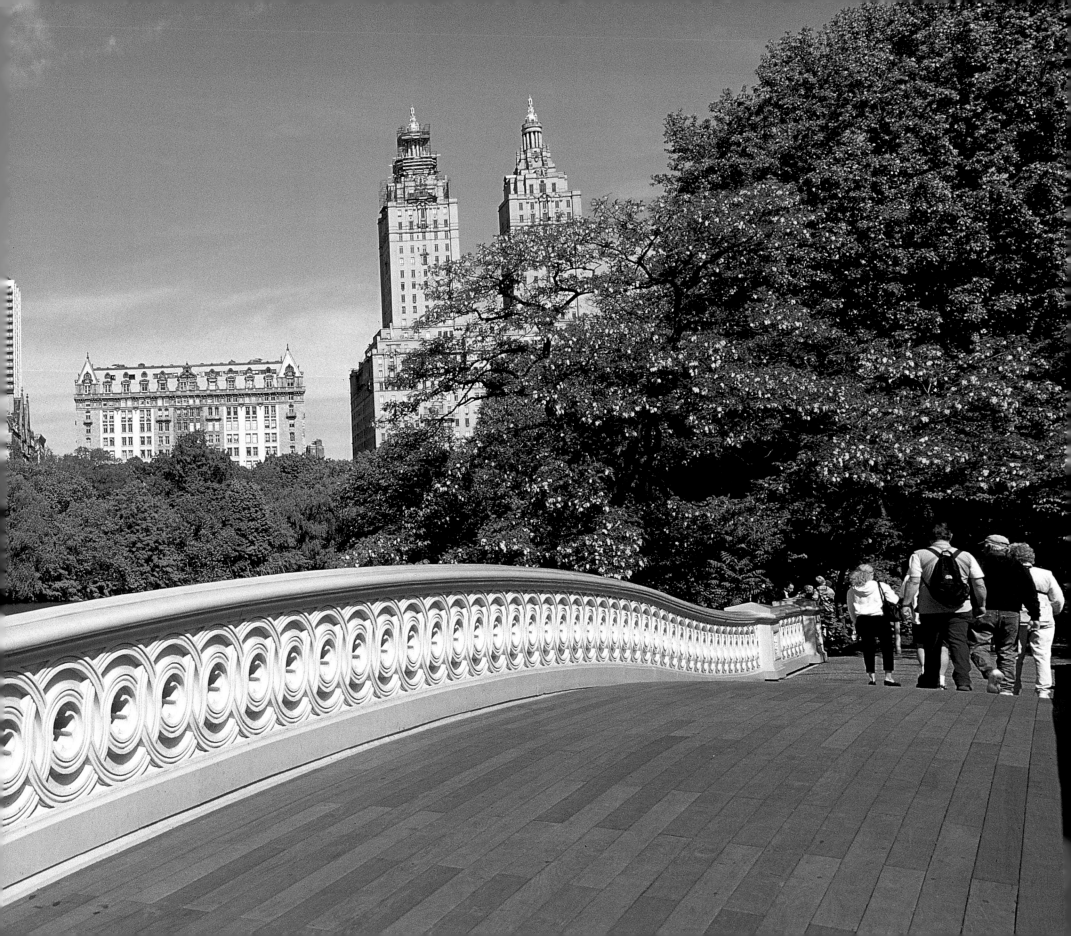

Metropolitan Museum of Art

"New York City is a place halfway
between America and the world."
— George Bernard Shaw

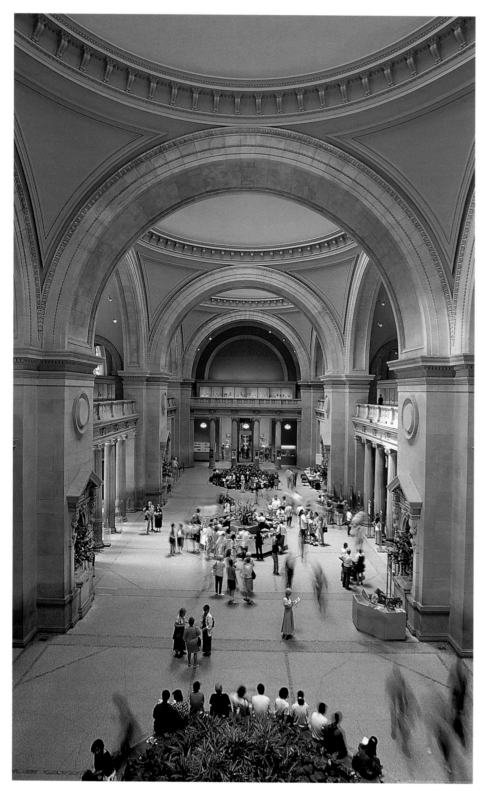

The Met's Great Hall is the first stop for most visitors.

Occupying four city blocks and containing over two million pieces, the "Met" offers the largest art collection in the United States. There are five major collections: European Painting, American Painting, Primitive Art, Medieval Art, and Egyptian Antiquities. Other highlights include the egyptian Temple of Dendur, a replica Ming Dynasty scholar's courtyard, and the entire Federal-style facade of the United States Bank from Wall Street.

Opened in 1870, the Met has been located at this site since 1880. There have been so many additions that the original Gothic Revival-style building is now completely surrounded by new wings. A new Beaux-Arts entrance was added in 1926. There are several buildings-within-buildings, courtyards, interior gardens, and a rooftop sculpture garden.

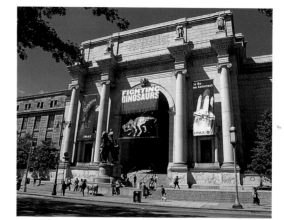

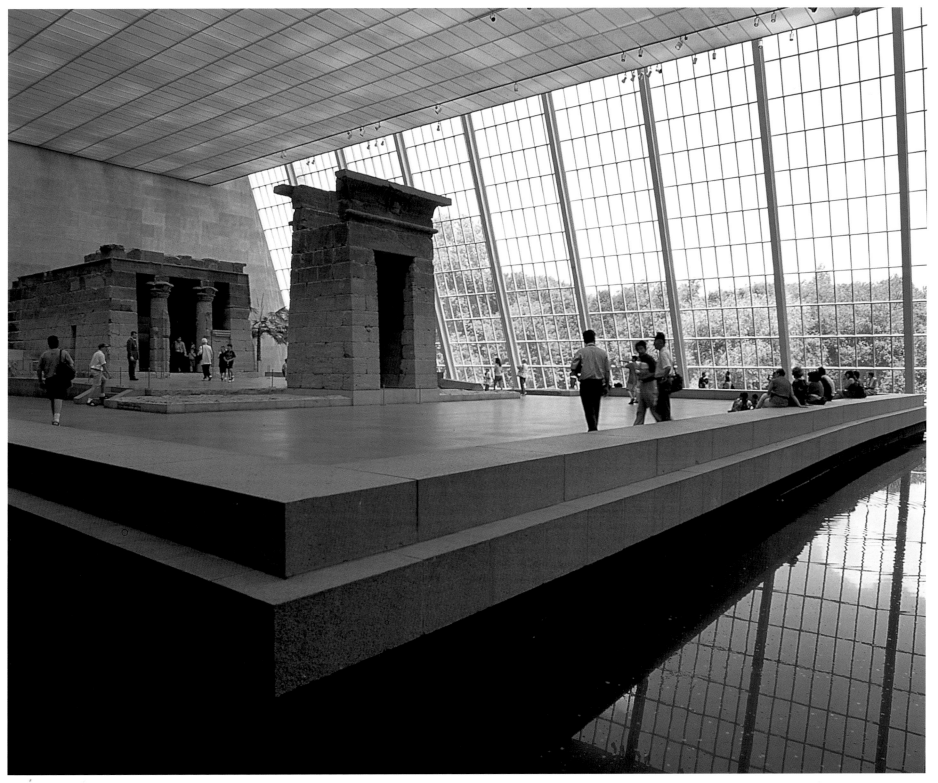

The Temple of Dendur dates from the 15th Century B.C.

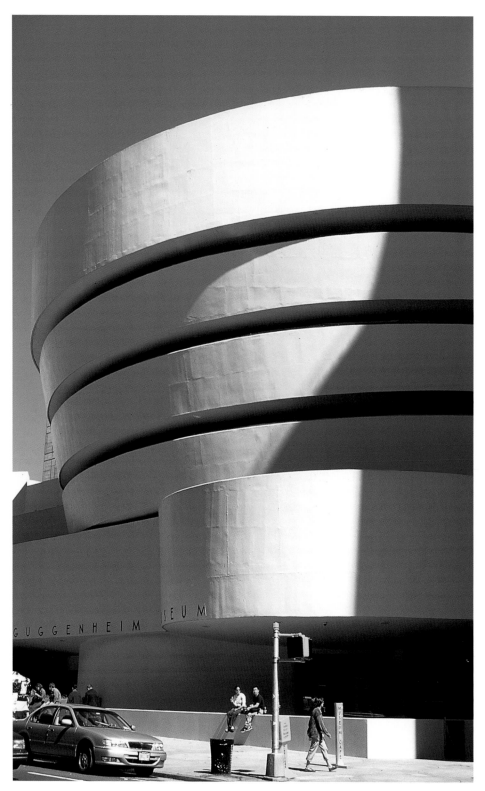

The Guggenheim

"I want a fighter, a lover of space,
an originator, a tester and a wise man…
I want a temple of spirit, a monument!"
— Hilla Rebay, Guggenheim's advisor,
to Frank Lloyd Wright, 1943

This modern-art museum is a work of modern art in its own right. Frank Lloyd Wright, possibly America's most famous architect, designed only one building for New York but what a structure it is.

The original section of the museum spirals upwards in a monumental swirl, creating a continuous five-floor viewing gallery around the atrium, leading up to a domed skylight. Wright called it "one extended expansive well-proportioned floor space from bottom to top… gloriously lit from above." The museum was commissioned by Solomon R. Guggenheim, a metal mining magnate, however both Wright and Guggenheim died before the building opened in 1959.

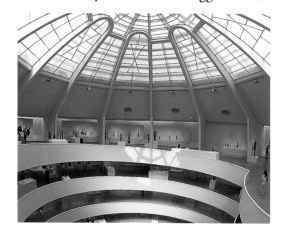

The distinctive Guggenheim sits on the corner of Fifth Avenue and 88th Street.

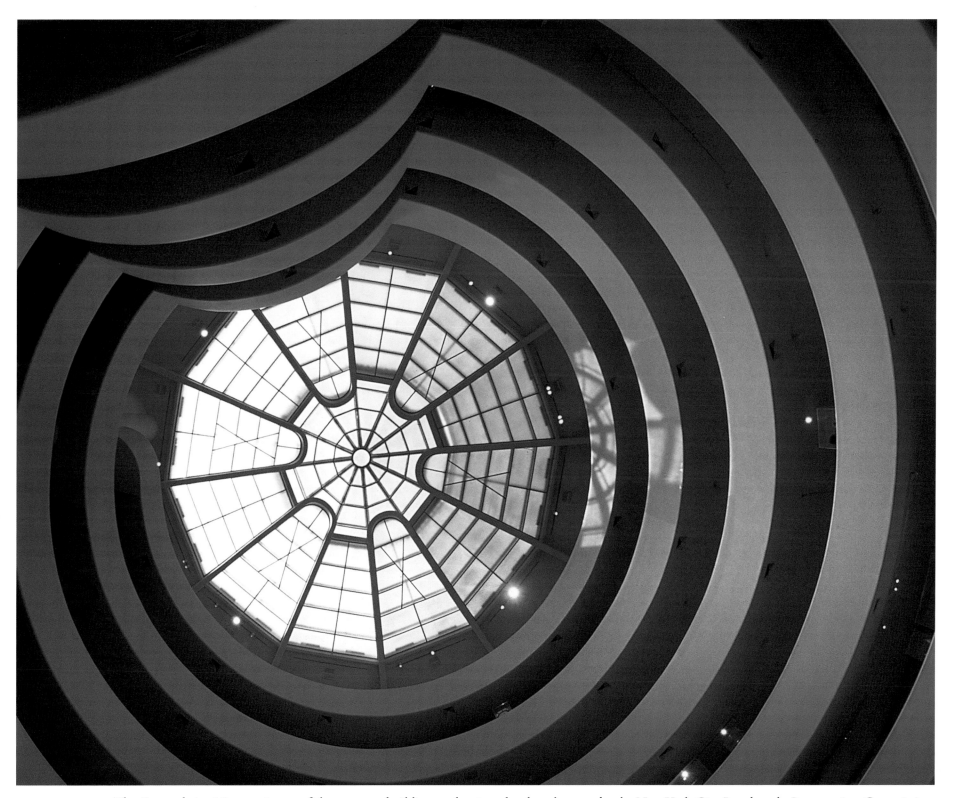

The Guggenheim Museum is one of the youngest buildings to be given landmark status by the New York City Landmarks Preservation Commission.

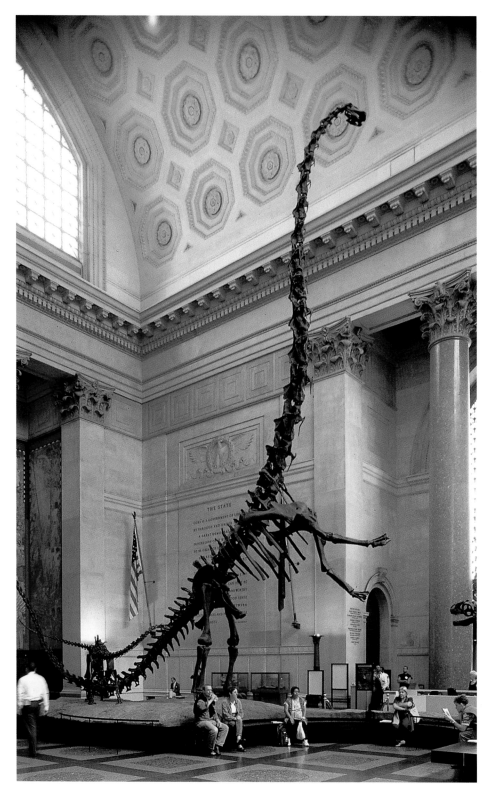

A 55-foot barosaurus skeleton in the entrance hall.

American Museum of Natural History

"Once you have lived in New York and it has become your home, no place else is good enough."
— *John Steinbeck*

The largest institution of its kind in the world, the American Museum of Natural History houses over 36 million artifacts in 19 buildings, and sprawls across four city blocks. Among the varied treasures housed here are the 563-carat "Star of India" blue star sapphire, the 34-ton Ahnighito meteorite, and a 94-foot-long, life-sized model of a blue whale.

Guarded by a statue of Theodore Roosevelt on horseback, the main entrance of the museum is actually one of several additions built around the original structure, which opened in 1892 as a sister building to the Metropolitan Museum of Art. The new Rose Pavilion of the Hayden Planetarium adds a Space Age flavor to this venerable Manhattan landmark.

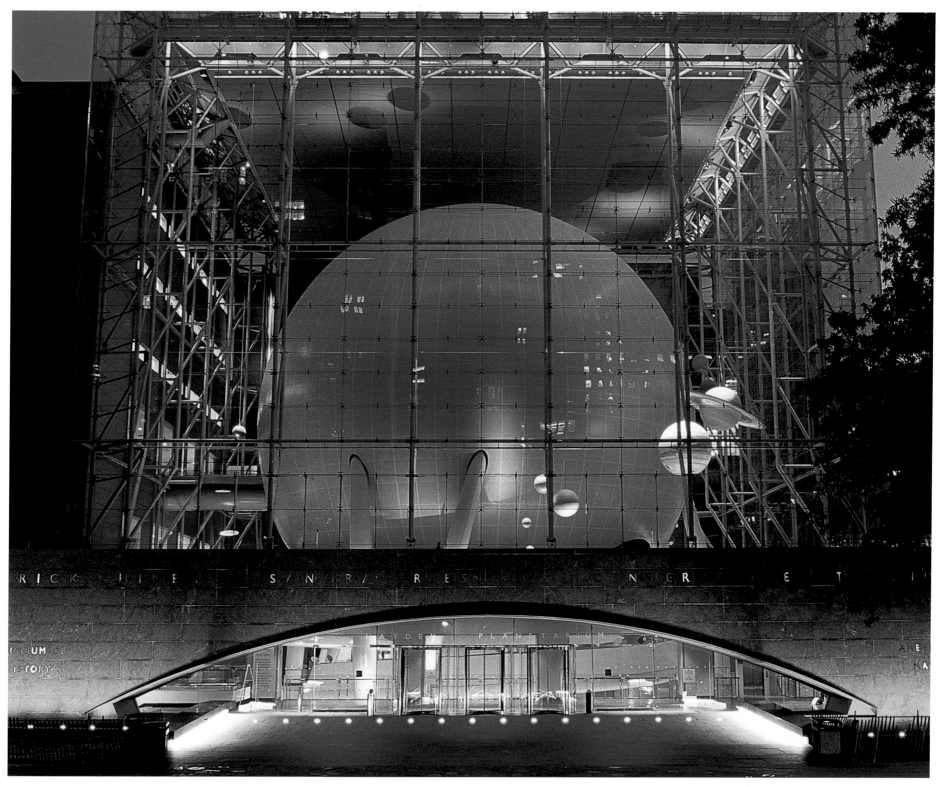

The Rose Pavilion of the Haydn Planetarium is the latest addition.

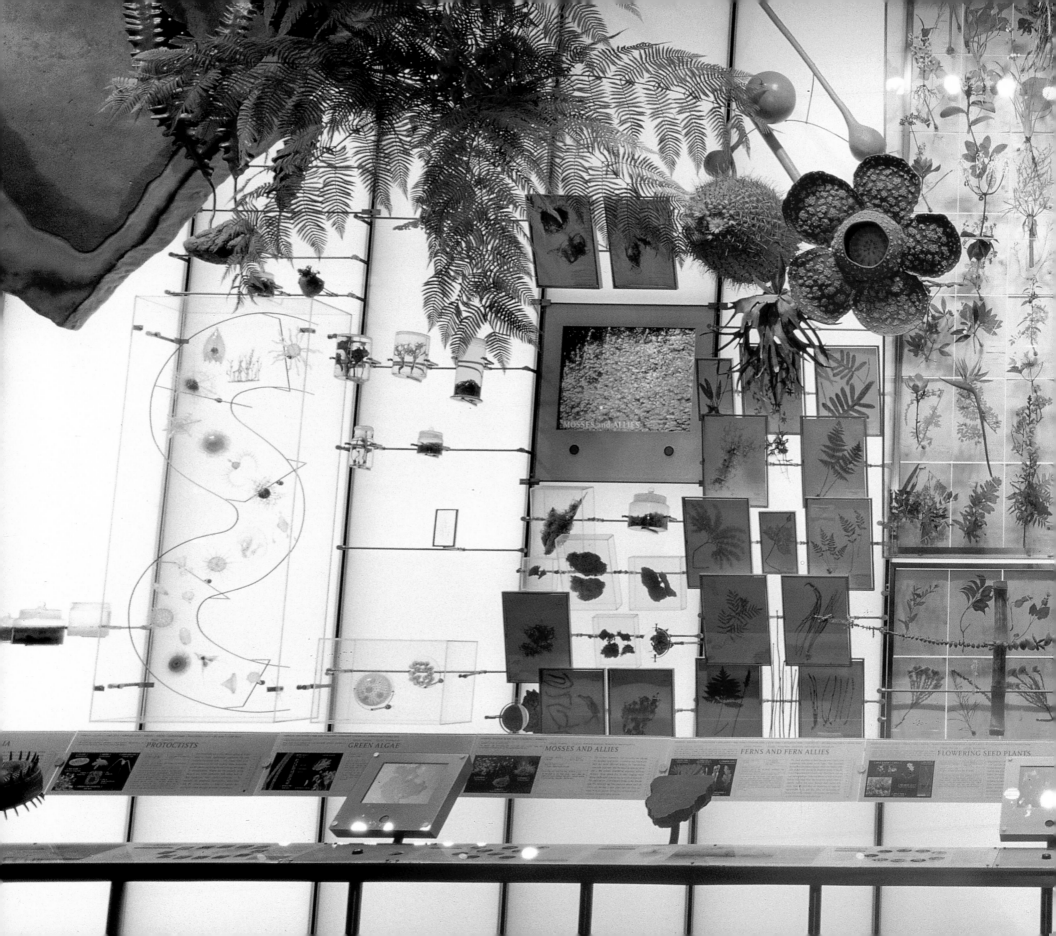

PROTOCTISTS

GREEN ALGAE

MOSSES AND ALLIES

FERNS AND FERN ALLIES

FLOWERING SEED PLANTS

MOSSES and ALLIES

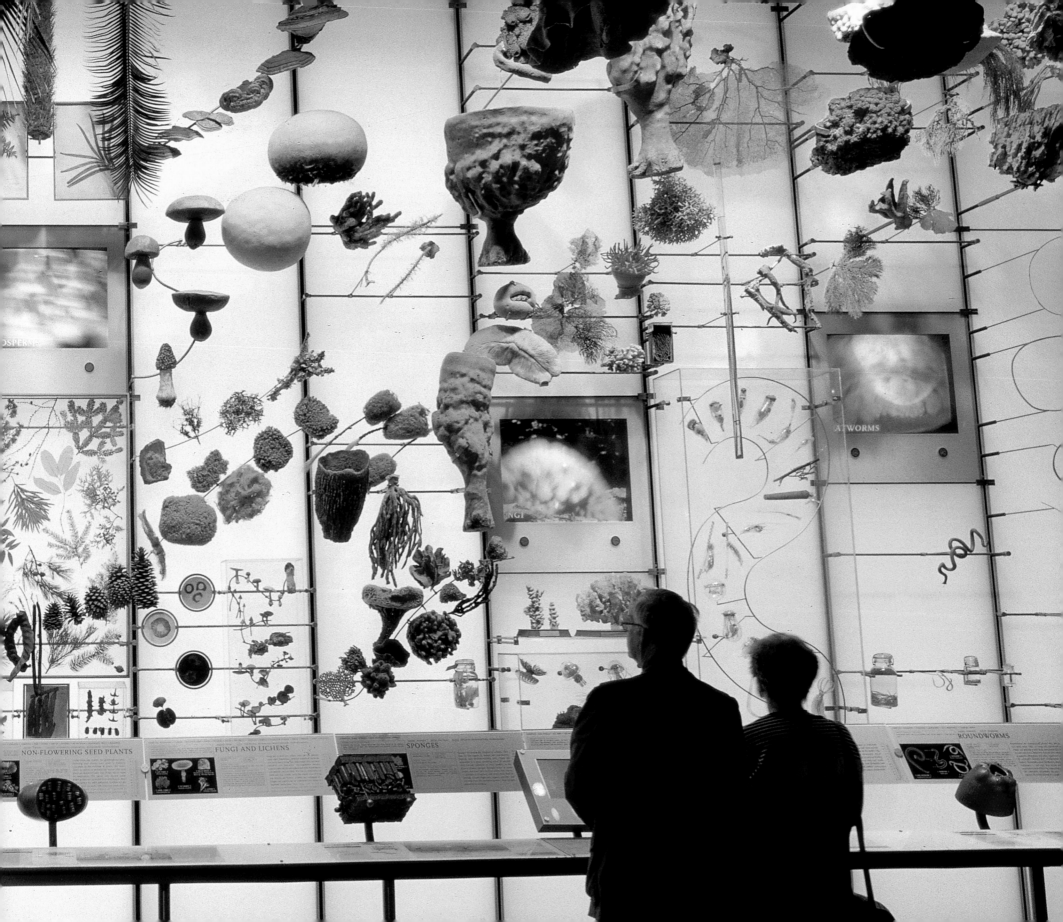

NON-FLOWERING SEED PLANTS FUNGI AND LICHENS SPONGES ROUNDWORMS

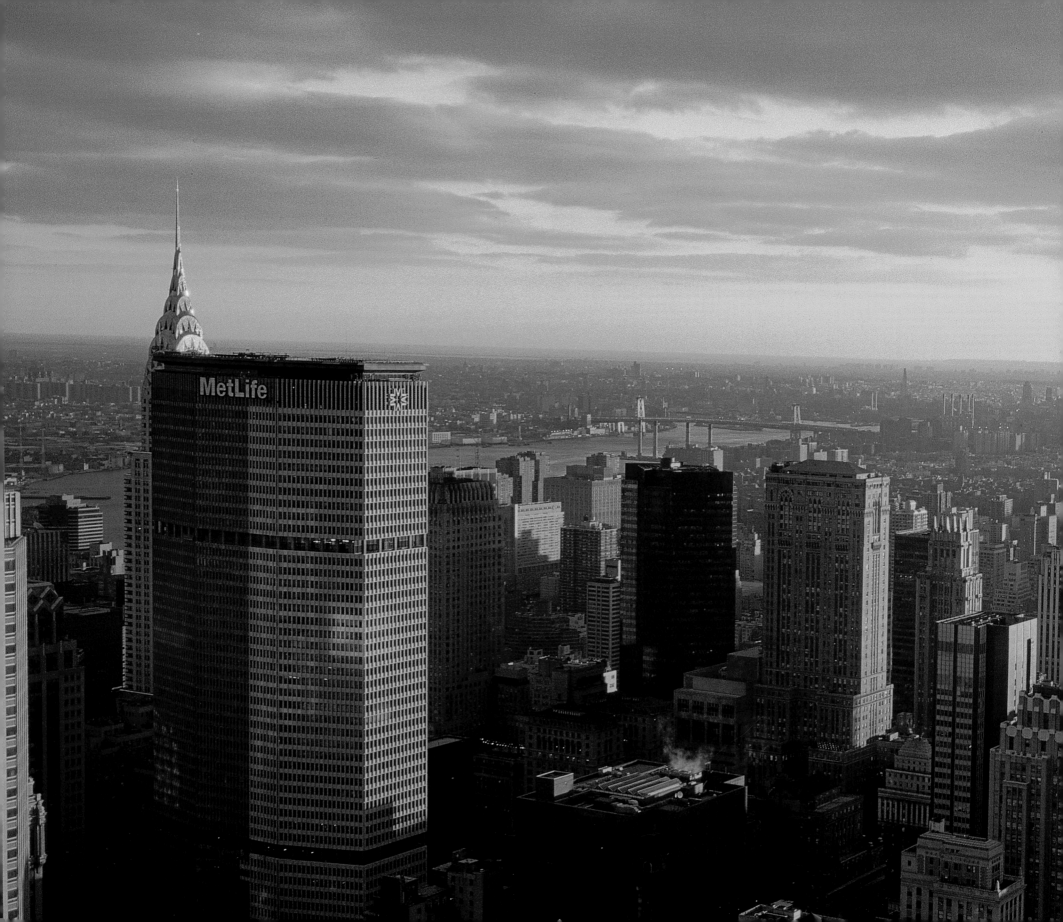

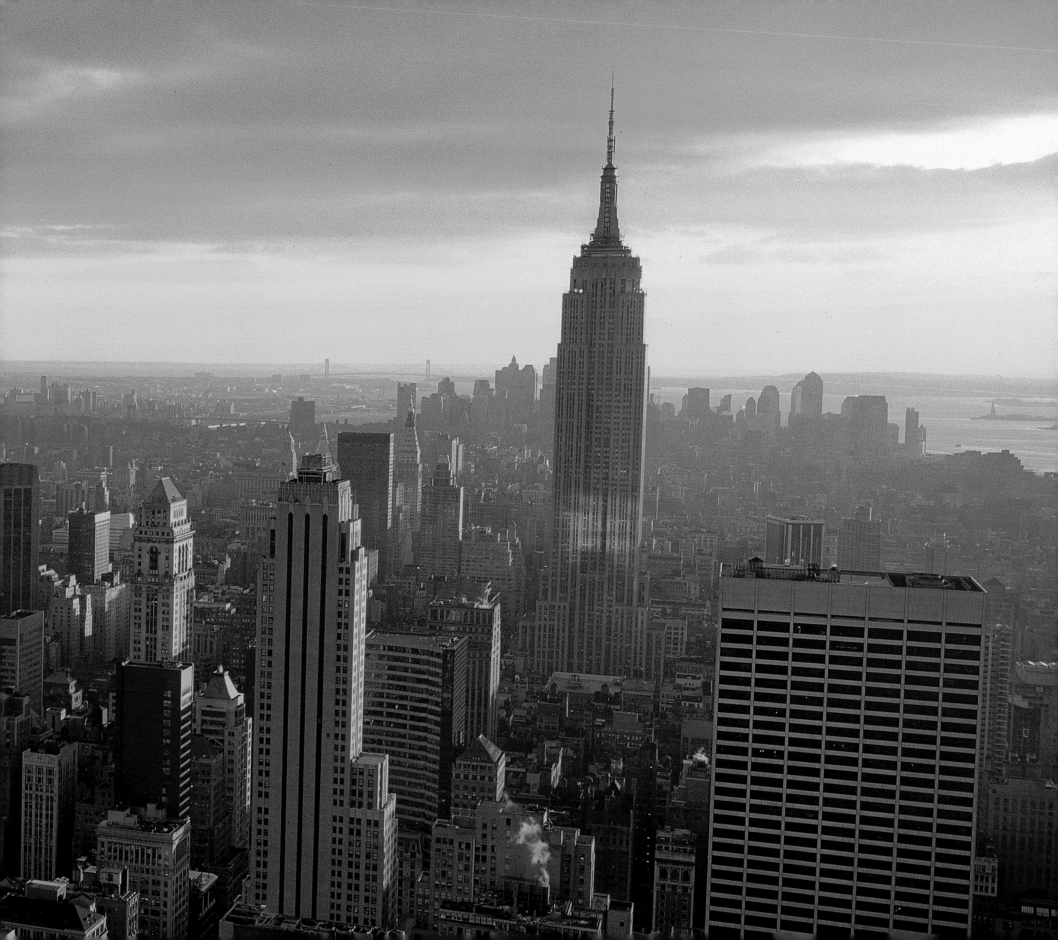

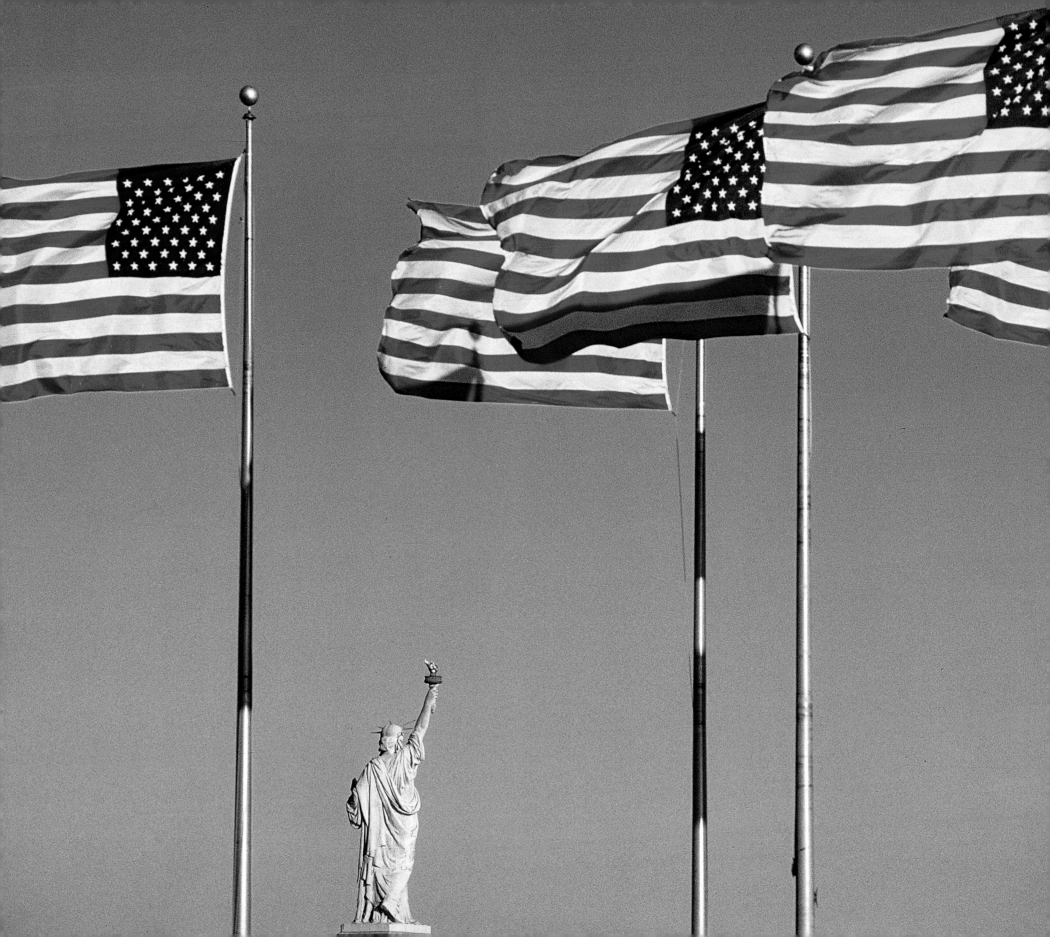

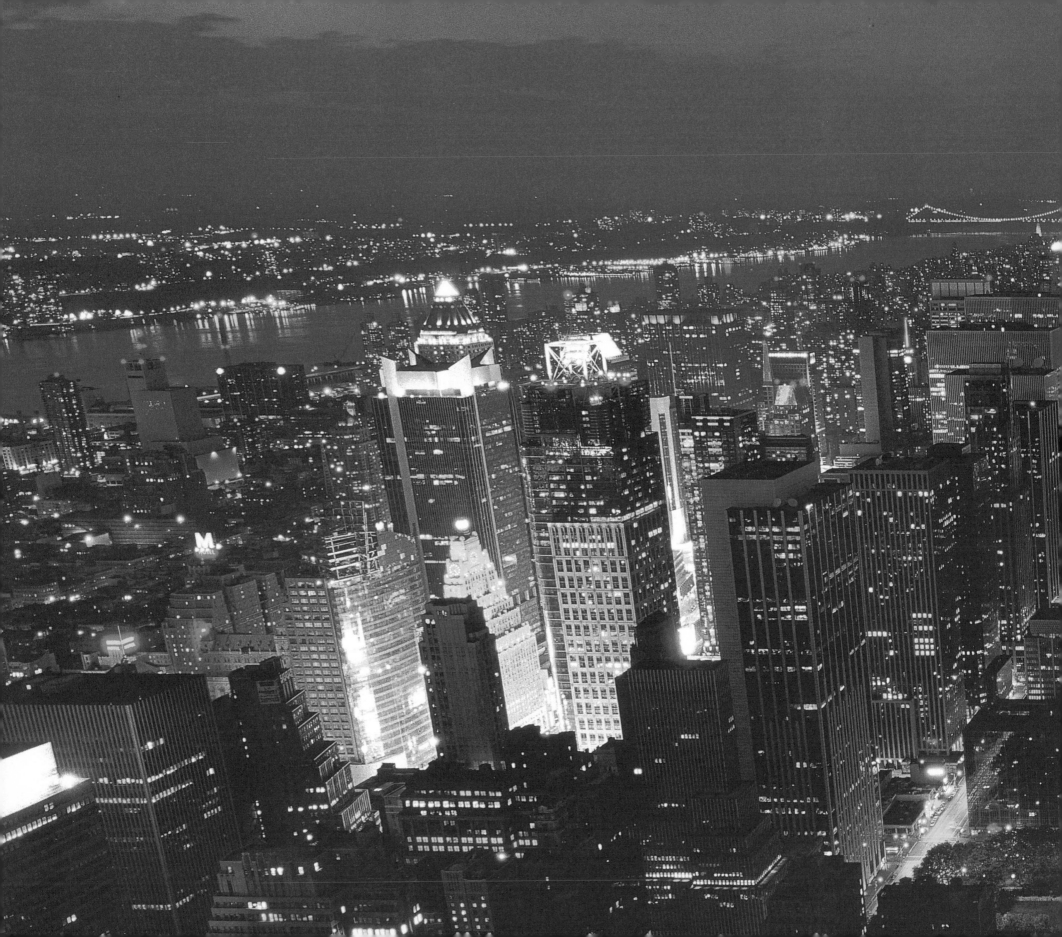